Stories From A World Of Music

Musicport 2011

Editors: Ian Clayton and Ian Daley

First published in 2011 by Route
PO Box 167, Pontefract, WF8 4WW
info@route-online.com
www.route-online.com

In association with Musicport Festival
The Port Hole, 16 Skinner Street, Whitby
North Yorkshire, YO21 3AJ
www.musicportfestival.com

ISBN: 978-1-907862-06-9

Editors:
Ian Clayton and Ian Daley

Writers:
Ian Clayton, Lenore Craggs, Ian Daley, Emma Jones
Jacky Lawlor, Deirdre McGarry, Rosemary Palmeira
Wayne Pearson, Heather Parkinson

Special thanks for their invaluable support:
Isabel Galan, Katy Johnson, Sue McLaughlin

Musicport would like to thank Robert Maseko for providing
the inspiration for the first festival and Arts Council England
for its ongoing support of Musicport's activities.

Cover image and illustrations:
David Owen
www.theinkcorporation.co.uk

Printed by Lightning Source

A catalogue for this book is available from the British Library

Contents

Being amongst friends
Foreword

A festival that brings international musicians to a small port on the Yorkshire coast, at a time of year when people are beginning to hibernate, could be a difficult concept to grasp... yet twelve years on it's still happening. What was supposed to be a one-off millennium celebration took off with its own momentum, carrying with it a loyal audience even through its move from Whitby to Bridlington.

There have been so many special moments through those dozen years and so many reasons why audiences and artists have engaged with the festival as they do. This book relates just a few of the multitude of stories that are woven into the festival and that contribute to the special, intimate feeling of being amongst friends as soon as the doors open. They hint at how people have embraced music as a positive force in their lives and how that force can unite, transform and transport us all.

In the early 1970s I worked in a hospital for people with severe learning difficulties. Amongst the many positive activities undertaken there was the engagement of the very first recognised music therapists. What came about proved something I'd always known but couldn't articulate: that music connects people whether or not we understand the words each other speak, and thus it is one of the most powerful weapons of change and understanding. We have seen the

transformative impact of music on the young people who have become involved with Musicport through education programmes such as NYMAZ and Music4U and we hope this book will inspire them in turn to tell their own stories.

The power of the music is undoubted and we celebrate it every day as we listen, sing or play – yet Musicport is more than just the music. Here are a few of my special memory snapshots.

Musicport 2000, and how people just appeared from nowhere for it... and by the end had made up their own minds that it would happen again the next year.

Tiris, a band from the Sahara, seeing the sea for the first time, the women leaning over the sea wall at Whitby, veils blowing in the wind, mesmerised by the sight.

Sunday morning of the first festival, the first note sounded by a soloist in the gospel choir, a group of us looked at each other with tears in our eyes and joyfully sobbed through most of their performance.

The doors that we'd just double-checked were closed suddenly blowing open stage-side during the Lal Waterson Project's performance of 'The Bird'.

Comparing notes with the great Linton Kwesi Johnson about growing up in Tulse Hill.

Desperately searching for cooking oil for the wonderful Czech singer Vera Bila to swallow before she could go on stage and sing.

The compere breaking down in tears along with most of the audience after Reem Kelani's performance in 2006.

Los De Abajo on stage during an electrical storm when all the electrics cut out – they carried on playing and were still perfectly in time when the power returned minutes later.

How almost every year, about two weeks before the festival, we say, 'That's it, we'll never do this again,' – and then it happens, it all seems so right, so many people enjoy themselves, there are so many fantastic performances, and we find ourselves saying, 'Next year we could…' and there's no choice but to start all over again…

The buzz amongst volunteers and contributors as two men called Ian, each with their special talents, took our ambition to make a book from a festival and made it reality.

Jim McLaughlin, Festival Director

Good blessings
Introduction

We were tucking into a delicious Sunday morning boarding house fry-up and our Edward said, 'Have you seen the artwork the Tibetan Monks have been doing?' I had to confess that I hadn't. I told him that I'd had a cup of tea with three of them and I'd smiled when I saw them watching a live feed from the main stage of some wild dancing. I said it was a bit incongruous that we were in Bridlington with Tibetan Buddhists in maroon robes nudging each other as they watched some African moves, but no I hadn't seen the artwork. 'You should look at it Dad,' he said, 'it's called a mandala, they've been tapping sticks and making it with one grain of sand at a time and today they're going to give it back to the sea.'

Later that morning, I talked to one of the people with the monks of the Tashi Lhunpo Monastery and he told me that even beautiful things like this mandala cannot last forever, and that in a ceremony it would be blessed and then put in to the sea so that the blessings could travel far and wide. I watched the ceremony then followed the monks down to the sea and saw the remains of the mandala washing away, taking good blessings on a journey.

Musicport is about journeys. We wash up here for one reason or another; some of us to be entertained, others to entertain, some to be helpful and yet more to share ideas.

We are on a pilgrimage, making an escape, striving for a bit of self-discovery, laying around, playing around and travelling on.

Musicport is a meeting place, gathered threads, a favourite deck chair in a row of them, a café, the shade of a big tree under which to while, it's a bandstand, or going to the pictures in the olden days… together. Musicport is human's being. Musicport is a festival I can't wait to come back to even as I'm leaving… a beautiful mandala.

At teatime on Sunday I looked through a window out to the sea. Egbert Derix, the Dutch pianist, was standing at the side of me. We just looked. He pointed out and said, 'Where is that over there?' I followed his finger and said, 'Well, Denmark eventually.' He moved his finger to the right, 'Holland' I said. 'I'll be sailing over to there in a few hours time,' he said. 'Yep, you and a lot of blessings.'

Musicport is like the tide. It comes and it goes then it comes round again, like all good blessings. In this book we have tried to capture some of the essence of this year's festival. Think of these words as little coloured stones amongst millions of others on a beach, something to pick up and put in your pocket.

Musicport is a pocket to hold a moment.

Ian Clayton, 7 November 2011.

Stories from a world of music
Notes On The Text

What follows is a series of stories that were told at Musicport Festival in November 2011. A team of writers were resident at the festival with a brief to capture 'stories from a world of music'. The conversations they had with over one hundred people were written down and fed into this book.

The stories are presented anonymously and arranged to reflect the rhythm of conversation over the three days of the festival. Incorporated into the book are a selection of notes that were handwritten on paper peace boats and left on public display. A sign above a table in the foyer invited anyone who passed to 'Add your message/thought/wish to the flotilla of paper boats that will be sailing this weekend in the windows looking out to the sea.'

Friday
Stories We Bring With Us

The vibrations in our feet
Arrival Stories

I was born with normal hearing but contracted meningitis at three months old. Mum and Dad rushed me to hospital but because I had fluid on the brain things didn't look good for me. The first scan I had confirmed it would be touch and go if I lived or not.

Mum needed to be alone but Dad stayed by my cot constantly. Although Dad would have said he wasn't a Christian, in desperation he prayed to God to save my life. His plea was sincere and I believe God answered, because two hours later I had another scan and the fluid had gone. God still has plans for my future, as do I.

I lost seventy per cent of my hearing, but Mum was determined I would have a 'normal life'. I went to regular school but integration was difficult. I'm not sure why but Mum and Dad decided I should have violin lessons, but I couldn't feel the sounds I was making so never progressed beyond basic stuff. Then came trumpet lessons and I found the louder I blew the more I could hear. I was blessed with wonderful trumpet teachers, two actually had hearing aids themselves due to loss of hearing in old age, but it's still the same thing.

I went for regular checks at Alder Hey Hospital and at the age of five they said I would be completely deaf by eleven. Then a check when I was eleven gave the prognosis

it would be fifteen, and so on and so forth. I'm twenty-three now and still have thirty per cent hearing; in fact there has been a slight improvement.

Doctors tried to discourage me from playing the trumpet as they were sure it would speed up the deterioration, as hard blowing and very loud noise causes damage. But the trumpet was far too important to me to give it up. I hear through my feet. I saw a documentary once about a DJ who had lost his hearing and he did the same. If we take our socks and shoes off we hear the music through the vibrations we feel in our feet. Although the DJ is now profoundly deaf, he still tours the world doing the job he loves. I am a music teacher now and tell my students that you don't play the trumpet with your ears.

Last year I was School Chaplain at Woodchurch School on the Wirral. It's a rough area and the kids would come to my room battered black and blue, to tell their story and cry. I'm honoured to have been in such a position of trust and able to comfort them. By helping them I was blessed with the feeling of wonder and achievement. I could make them smile, some of the kids were taking steroids to build muscles and I would joke with them about the bit of bum fluff on their chins and their Arnie figures. Jokes diffuse a situation and help create a common bond through laughter, as does music.

Me and my dad have had some tough times in the past but now he's my best friend and embarrassingly proud of me. For example when we arrived here and booked in at the B&B, the first thing Dad said to the landlady was that I am a partially deaf trumpet player, have played at Buckingham Palace and been on the TV and that I will be playing with Goldie's band at the Spa. Embarrassing, but he really is my rock.

I cannot believe I have been on the same stage playing with these amazing people, I'm a bit awestruck with it all. Lester and Natalie are kind of heroes to me, they have overcome so much. Lester's songs are so real, he writes about what he has gone through, I'm very proud to be his friend.

I have a music ambition, and it's a bit of a weird one; what I'd love to do is combine the trumpet with Celtic music. The trumpet sticks out in any band but just like me, can be very subtle too. But my main ambition is to raise the profile of deaf people. We live in such an average world with little room or understanding of difference. I think a lot of deaf people are stuck in their own shells. I'd like to show them they are more aware than they know, and there are other ways of hearing. They can be more tuned into society generally.

When people talk to me, they do so in a different way, I say to them, 'Don't be a divvy, I'm only deaf and not even all that deaf, talk to me properly.' I am who I am because I am deaf. If I was fully hearing I would have developed into being someone else. My music, my faith, my family and my ambitions are my future.

★

When you are on your feet all weekend, running from stage to stage and dressing room to dressing room with odd and not so odd requests from legendary musicians, you need to change your shoes often to ease the pain. Alternatively you need a very comfortable *sensible* pair of shoes. So, on my way here I was taken to a shoe shop by my grandma, mum and dad. But this isn't just *any* shoe shop, it's a very special shoe shop. It's tucked away in a

corner of Bridlington and has a wonderful window display of sensible shoes. Go through the door into this magical tiny world lost in another time and you will find walls made entirely of shoe boxes.

The lovely eighty-six-year-old man hobbled to the door to greet us. This is the same man who sold school shoes for my mum's hard working school days, the same man who sold shoes to my grandma for her first date, and the very same man who sold shoes to my great grandma. I was looking for something specific but couldn't see anything I fancied… maybe these shoes were *too* sensible! 'Doc Martens?' I asked. He hobbled along to one of the columns of shoe boxes and took some shiny oxblood shoes out of the crinkly paper. I felt like a princess as he placed the shoes carefully on my feet, adding a complimentary insole to my slightly more spacious shoe and even tying the laces and checking that I could stand correctly in them. How wonderful to have that level of service and to be made to feel that special before a gruelling yet wonderful Musicport Festival in Bridlington.

<p style="text-align:center">*</p>

In 1967 I was seven. In order to avoid expending any imagination thinking about where to go on holiday, my mum bought a holiday home in Ulrome. Even then the coast was eroding, as it still is now. I know all the villages round this area really well because from being about nine I used to cycle in a twenty-five mile radius all over – Nafferton, Kilham and as far west as Wetwang. I remember hearing Desmond Decker's 'Israelites' and 'Young, Gifted And Black' around that time. That made a big impression on me.

This hall, the Spa at Bridlington, was a really big rock

'n' roll venue. I think it was all happening on a Sunday when people like Ken Dodd had a night off, but I never saw anybody here. My sister did though. She saw Rod Stewart and the Faces in 1972 – before he got fascinated with blondes in America – and Ziggy Stardust and David Bowie. Me, I saw nobody. We lived in Rochdale and the first time I got to see anyone was Rory Gallagher at Manchester Free Trade Hall when I was fourteen in 1974. That was when we stopped coming over here on holiday.

★

I've come to Musicport to get topped up with music before the winter sets in. It gives me such a feeling that is hard to describe, but is essential to my life. Good music gives me an intense feeling inside, the vibration ignites every cell in my body.

I do love drums and percussion. I can't really listen to music without them. I think this all comes from when I was a young girl and would dance at home. It was all about the rhythm and the vibrations. It still is.

★

One of my constant companions to these festivals over the years is a friend of twenty-five years, who is deaf. Music is about vibration and feeling, and hearing music is only a part of the experience. Yet here is someone who can probably tell you more about what I'm hearing than I can. Music is a sensation that is experienced in more than just an audible way. Listen to what your body feels rather than what your ears hear, then you'll know what a deaf person experiences from music. And, if the words are in English, they can be lip-read too.

Conversely, my partner doesn't like so-called World Music and thinks it doesn't travel. Maybe she has a point. But it speaks to me loud and clear, and the world would clearly be a poorer place without Musicport and WOMAD.

<center>★</center>

I'm a Tibetan monk. I was born in Northern India. I've been a monk for twelve years. I joined when I was eleven. It was my choice.

I've only been in England for two months. I live in Glastonbury. When I came to England I was surprised at how clean everything is and how people are so punctual and careful about time. In my country ten o'clock is eleven o'clock.

I've come to the Musicport Festival to do a Mask Dance and to do chanting and meditation and to make a sand mandala with a group of other monks. I love dance music particularly classic Western and Tibetan religious dance music. I have a spirit that always wants to dance. In meditation we use a singing bowl to start the meditation.

I've never seen or heard music like this at the festival before. It is all an amazing experience for me.

<center>★</center>

One reason for me to come to Musicport this year was that I'd been asked to interview Andy Kershaw on stage in the theatre. I went through his book *No Off Switch* with a fine-tooth comb, made sure I gleaned everything from it that I needed to and then prepared a mental list of what I would ask. Andy phoned me up the week before and wanted to plan out what we should do; he wanted to prepare a slideshow of photographs to go with what I

would ask him. I spent a day preparing twenty-odd questions. He followed up his phone call with a number of emails. I got the impression that Andy likes to be well prepared, polished and professional. I thought I'd have to be on the ball too.

On the Friday night, as I was walking in to the Spa, my mobile rang. It was Andy. 'Hello Ian, I'm in Hull.' I asked him what he was doing in Hull. 'Well believe it or not this is the best route to Bridlington. I flew from Douglas to Manchester then got a train from there to Hull and now I'm waiting for one up to Brid. I used to have my holidays there with my mam and dad, I've got happy memories of them times. Can we meet for a chat?'

Andy arrived with a rucksack on his back and his trademark BBC box. We went straight to the green room, he pulled out his laptop and wanted to crack on straightaway with his slideshow. I hadn't had anything to eat, my head was full of arriving and expectation, I didn't know whether I was coming or going and Andy was explaining in detail his photos of Nelson Mandela, The Bhundu Boys and the bloke from The Tonton Macoutes who put a gun to his head in Haiti. As he launched into a tale about Live Aid I had to shoot off to find my family. I left Andy to sort out his slideshow.

There's an old Dutch proverb that says 'Putting up the tent can be as fine as the circus.' Arriving here on Friday felt like that to me.

★

I'm always bumping into old friends here. I'd only been here two minutes, hadn't even got my wristband on when I met up with Ian, a mate from County Durham and his

friend Derek. I only ever see Derek here at Musicport, I see Ian at the Cambridge Festival. We don't write or phone each other in between, just carry on with a conversation we were having months before. My granddad had a vulgar expression for these kinds of friendship. He would say, 'With some people you don't need to be up their arse all the time, if they know they're your friend, it's enough.' My old granddad had some weird sayings.

As we were talking Pete and Eileen from Doncaster turned up, there was another of those 'Nice to see you again' moments. Pete and Eileen go to Cambridge and they know Ian because they talk to him every time they go for an ice cream. I left them to catch up, and when I walked past an hour later, they were still gassing.

<p style="text-align:center">★</p>

From Blackpool, turn right for Brussels and Balkan traffic then follow the signs to Bridlington. Well, that could describe my journey in a year but I'm not sure if a journey can be measured in time or more as an experience.

<p style="text-align:center">★</p>

I cried on the way to the Musicport Festival as I passed a shop with a sign in the window advertising dressed crabs. This reminded me of my mother who passed away recently. When I went to the yoga workshop, I met a woman called Vivien; an installation artist who was making origami yachts. You could write messages on them so I wrote, 'For Violet; I'll always remember you'. Then I thought about the dressed crabs sign from earlier and I wanted to make another boat but this time with a picture on it of a crab with a pom-pom hat.

★

My initials are SEAD
And I feel I come from the SEA
Musicport brings out the mermaid in me
As I dance and feel free

Where the fun starts
Previous Gatherings

When Musicport first came to Bridlington, the shower in my B&B was circa 1910 and was cold water only. So on the advice of Jon, the stage manager of the theatre, I used the disabled shower backstage. It was a bit of a rush between organising the front of house for the next act, but a necessity. So in to the shower room and I dropped my clothes in a heap on the floor. Bliss, the joy of a hot shower. I stepped out on to a wet floor and the horrible realisation that it was a wet room. So; wet room, wet floor, wet clothes!

After a brief moment of tears, I grabbed for a towel and shouted around the door to the Spa backstage staff to go and find Jon. When they stopped laughing, that's what they did. I then had to sit in my towel and wait while Jon rushed around to find me (as he put it later) an XXXL Musicport t-shirt from the front desk to hide my embarrassment and to organise a driver to take me back to the B&B for a change of clothes.

It's funny now, but at the time simply one of the most embarrassing moments of my life, never mind Musicport.

★

The first Musicport Festival I went to was all a bit of a shock. I ran from side to side, stage to stage, outside, inside,

for the entire weekend. I had about nine hours sleep in total from Thursday to Monday and ate my own bodyweight in poppadoms and dips. That year, the green room for the artists was upstairs, where the film room had been for the last few years. And that's where the end of the weekend party was – after all the festival goers had left. The hall feels empty and a little odd when everyone has gone but the green room was packed full of exhausted people with a second wind the likes of which I had never seen before. There was an eclectic collection of instruments from koras, fiddles, saxophones, bongos, guitars, clarinets and they were all being played very loudly by amazing musicians.

Reem Kelani – the beautiful Palestinian singer who had given a wonderful debut performance of a collaboration with a young Fado singer, Liana – had a burst of post-midnight energy to whip everyone into a musical frenzy. She floated around the room, waving her arms manically, shouting, 'Sing! Play! Come on!' No one was left out. I was still dazed by the sheer amount of music I had experienced during the weekend and lost myself in the magical cacophony in that sweaty room. Eventually I drifted outside onto the balcony and stood in the dark, listening to a mixture of waves crashing against the sea wall and the creative madness which was happening inside. With my voice nearly gone and my legs aching.

★

When Ustad Mahwash sang at Musicport with Ensemble Kaboul, I was to introduce her. I stood at the side of the stage trembling. Here was an Afghani singer who had escaped the Taliban and was living in exile. At one point

she had been poisoned by her family, who didn't want her to be singing. I thought about some of the journeys people have to make, the things that they have been through just to stand on this stage. I became profoundly aware of the weight of that moment, a mere 'Please put your hands together and welcome to the stage…' somehow didn't seem enough. I read out some pieces from the biography she had sent. She put on an incredible performance, it was one of those Musicport moments and there have been a lot of those over the years.

<center>★</center>

When my son was in Barcelona, he lived downstairs from the singer of a band called Go Lem System. He got to know the band quite well. When we organised a special birthday surprise for my wife Sue, we went to a house in the hills above Bilbao and my lad brought along a tape of Go Lem System. It was the only music we had that week and we loved it. Sometime after, the Cuban singer Yusa was performing at the Compass Club back in Whitby. At the end of the gig, everyone still wanted to party so we brought out a Go Lem CD. They all loved it and got on to Jim to book them for Musicport, and that's where the fun starts.

Budgets are always a consideration, I offered to pay their airfare but of course work permits are the next thing. There were a couple of Catalans in the band, a Venezuelan and two Argentineans. I think the Catalans were okay for visas, the Venezuelan had a Swiss passport so he was alright but we had one or two hiccups with the Argentineans before we eventually got sorted. My son drove them up from Stansted. When they arrived at our house, it was like

receiving royalty. They played and went down a storm and sold every CD they'd brought. I then got them an agent and not long after they toured Britain, I saw them do their last gig on Princes Street, Edinburgh. I think Sergio went back to Argentina, Anxo is playing with other bands and Aleko, the singer, Joni and Jim the Venezuelan are in a new group called Planeta Lem.

★

I'm usually a steward here, but last year I got to play the South Sea Stage. I was slightly disappointed because I was on at the same time as John Cooper Clark in the theatre and The Urban Gypsies on the main stage. All the crowds walked past me one way or the other and I probably got half the audience I was hoping for. The following morning, Rachel who runs the North Sea Stage said to me, 'Have you got your guitar?' I told her that it was under the table. I was standing next to my mate Phil who plays mandolin and fiddle. Rachel told me that there had been a mix-up over at The North Sea Stage, the room was heaving, every seat taken and there were people lined down the walls. She said some flamenco dancers had been given the wrong time to come and their was an audience waiting for something to happen. 'Will you play? There's a ready-made crowd.' I did three-quarters of an hour and played my own songs. Phil came and joined me on some of the numbers. We didn't plug in, we just played. They introduced me as a busker. I had to tell them that I wasn't a proper busker, but I'd heard there was an audience waiting. It was magical. The whole room applauded me. It was early afternoon, I was looking through the windows and out to sea, the tide was in, just bliss.

★

We'd both been in relationships without music and Musicport at Whitby was our first festival together. We loved it, so we came back the following year and had our honeymoon here – because of the dates for Musicport that year, we had the honeymoon three days before the wedding. She is more folk, I'm more reggae, but together we love the dancy, funky African stuff with horns.

★

When I came to last year's Musicport I was still recovering from the loss of my dad. I hadn't been out for a year. It was the perfect festival at just the right time for me, I found a whole new world of music and culture out there to discover. My mum said afterwards that coming here had changed me. It gave me a new interest and focus just at the time when I needed it the most.

Recently it was in the news that The Who were to play at one of the big Olympic events next year. My mum said that they should forget about The Who and book The Imagined Village instead.

A rainbow that arched over the stage
Reporting Back

I recently went to Fleadh Nua, a traditional Irish Music festival in Ennis. I hadn't anticipated going, but had just left my boyfriend – things were not working out – and I had some days free and came to Ennis. I had to stay in the youth hostel as I couldn't afford more, and was put in a mixed dorm.

One of the roommates was Ian – an Australian accordionist – and he took me under his wing, insisting on accompanying me at various points in the festival so I could come back late – sometimes till 4am – without a problem. The deal was, he'd escort me and I'd take the photos.

He lived in the Bush in Queensland and played at Bush Dances where people came from hundreds of miles around. He'd bought the accordion on a previous trip to Ireland, took it back to Australia, learned to play and now wanted to play it in Ireland.

He had met Blackie O'Connell, player of the Uilleann pipes, on Facebook, and now wanted to meet him in the flesh. Uilleann pipes are like bagpipes only they lie across your lap, you put the bag under your right arm and pump air into it with your elbow, and the chanters hang down. The story is that when the English occupied Ireland, they made it illegal to play the pipes, along with forbidding

Gaelic and Roman Catholic worship. They were devious because what they said was, 'You can't have the chanters above the shoulder' and hoped that would stop them playing. But the Irish are an ingenious race and found a new way of playing, with the chanters hanging down and strapped around the waist.

So when I saw Blackie – so named for his really, really black hair – it was in the corner of a heaving pub. He was young but very highly regarded. There was sport on TV at one end, and this massive event at the other end, people with drinks, laughter and the 'craich'.

When Blackie played, he was transformed, and gradually everyone else joined in until they were transformed too. He just closed his eyes and went into it – like a trance – and his whole body was playing, like every part of him was oozing from the pipes, and he was pulling things, deep out of himself.

He went from fast to the saddest, loneliest, most heart-rending sound – and he just made me cry in the pub. Ian looked over from the other side and motioned to me – I gave him the thumbs up and patted my chest. The next morning I wrote my poem 'Piper' and read it to Ian at the other end of the dorm. How strange, sharing this with a man from the other side of the world. He asked for a copy to send to Blackie on Facebook. When I came home I realised how much I had been blessed through the pain of losing my boyfriend.

★

I was in Iceland on holiday with my wife and daughter and we decided to try and go to a really remote place. We'd read about a place called Laugarholl in *Lonely Planet* which

said there was a very remote hotel there that hardly had any visitors so always had vacancies. After travelling for two days via Holmavik in the Westfjords – mainly over dirt roads – we arrived at the hotel and asked for a room. We were told it was fully booked.

I heard a hammering sound come from the backyard. We were in luck, they were erecting a stage for a concert the following day, so we set up our tent in the camping area.

The next morning we went out for a walk. There was only one road to this place and the ticket collection point was twenty miles down it. Because we'd arrived the previous day, we got in for free. Around 1000 people had made the trek out there.

It tuned out the band playing were Sigur Ros, Iceland's most famous band. During the concert there was a bit of light rain and it created a rainbow that arched over the stage. It was the best concert I've ever been to. Later the band were camping in the campsite we were on.

★

I was in Derby and I saw that the Chemical Brothers were playing that night in Sheffield. I'm not normally an impulsive kind of guy but I decided on the spur of the moment that I would go. So I drove over to Sheffield in my knackered Jaguar, and arrived at the Octagon where the gig was held. It's called the Octagon for the obvious reason that it is actually an eight-sided building and the speaker arrangement was such that they had placed them on all eight sides of the venue. Of course this enabled the concert to have surround sound instead of the usual set up of all the speakers at the front. It wasn't loud but the fullness of the sound cut to the very essence of music, pure

rhythm. This appeals to everyone on a very primal level and we all respond to that. I've never taken drugs in my life, but I didn't need to, it was totally absorbing and such a clear experience. I could hardly see the guys performing, they were quite hidden, I only caught glimpses of the occasional button being pressed. At the end of the night the doors opened and there had been such a sea of sub-bass you could almost feel it pouring out like a liquid soup onto the streets outside. It was incredibly tangible. I couldn't listen to any other music for ages after that night; it felt like that was all there was or ever will be.

★

I was privileged to see Mariza the legendary Fado singer in a tiny venue in Gateshead. The Caedmon Room was an upstairs room in a library, set out café-style. We managed to get a table near the front, there were no more than one hundred people in the room. She made her entrance beautifully, singing before she appeared; when we did see her she was statuesque in taffeta and shawls.

For the second to last song she unplugged the microphone and came into the audience to sing at the tables. Suddenly I felt Mariza's breath on my shoulder, I wondered whether I dare look round into her face. I could hear the silence all around. At the end of it, everyone was just speechless.

★

I was in one of the first all-female rockbands in Denmark called Hos Anna from '75-'80. The other female rock band at the time were Shit & Chanel. People thought we were rivals but we became great friends.

I have been in The Jungle Fever Orchestra for thirty years. It's a ten-piece band and we've played in over fifty countries from Greenland to Tasmania. I have never known such an enthusiastic audience as the Mexican people.

The lack of female performers today is of great concern. In the 60s and 70s when the Womens' Lib was in its heyday, there were a plethora of female instrumentalists performing, in fact it was lonely for the boys. These days young girls only want to be singers. They don't have the determination to become proficient instrumentalists. It has become such an issue in Denmark that I and my contemporaries have spearheaded a movement to encourage women into music.

★

I went with my friend to WOMAD a couple of years ago and we were in a marquee watching a DJ with a rapper. The atmosphere was electric, full of youngsters but there was a handful with grey hair at the back. My friend said, 'It makes me feel old', to which I replied, 'It makes me want to dance!'

When I took my niece to WOMAD last year we were in a dance tent bopping like mad together. I thought how fabulous it was that a 15-year-old and a 50-odd-year-old could bridge the generation gap and share the same love of music together.

★

I was at the Isle of Wight Festival in 1969. We had to queue four hours for fish and chips, and two hours for the loo. Still, it was very social, generally friendly, with some people stoned. Bob Dylan came on at 2am. He was so far away

he looked two inches high. My friend and cousin had fallen asleep.

<div align="center">★</div>

We travelled down from Stranraer to Bath, there were three of us, wet behind the ears, young lads. We didn't know much about the world at large and we were horrified to find a young couple making love in a sleeping bag next to us. When a man came by, shouting 'acid, acid, acid' we wondered why on earth anybody would want to buy acid at a music festival. We were thinking about the sulphuric kind. Pink Floyd were playing stuff from their album *Atom Heart Mother* which was just out. I fell asleep. My mates thought I was groovin' to it.

I only went to one other festival after that. I went to Lincoln with my wife, the Beach Boys were on, we camped in a field of winter wheat. The toilets were so dreadful, that was the end of that.

<div align="center">★</div>

For my fiftieth birthday party we had pies, potted meat, boiled ham and a roast sirloin of beef from an old fashioned butcher. A little microbrewery brewed a special bitter at five per cent which they called the 'Big Five-0' and Tetley Dave said we could use his concert room. I say concert room, it's just a traditional lounge in a backstreet boozer with a stage at one end as big as a bar tray and complete with a PA that sometimes works.

I'm lucky that I have musicians as friends and loads of them agreed to come. Ray Hearne, the folk singer from Wath-on-Dearne, kicked things off. He sang my favourite song of his, 'Thurnscoe Rain'. It left me with a lump in

my throat as big as a piece of coal and it was still only eight o'clock. Chumbawamba did lovely acoustic versions of songs from their then latest album – 'Add Me', 'El Fusilado' – and then persuaded me to get up and do the Johnny Cash song 'Folsom Prison Blues'. I certainly did it; don't know if I did it any justice mind, but did it all the same.

My mate Graham Oliver, lead guitarist with heavy metal rockers Saxon, was en route from Sweden to America, but made time to come. He did a fantastic jam session with a working man's club turn on bass, the blues harmonica player Andy Prowler, Andy Dawson on slide, our Eddie, who was twelve at the time, on keys and Steve Huison, who was playing Eddie Windass in *Coronation Street*, on drums. They did 'All Along The Watchtower'. Jess Gardham, the funky folk singer from York called in at midnight on the way back from a gig in Huddersfield to round the night off.

I think everybody enjoyed themselves, including my middle-class next-door neighbours, who, when I'd invited them said they weren't sure about 'your sort of parties'. Alice Nutter told me later that my neighbours had spent half the night trying to persuade Chumbawamba to do a gig at the Golf Club's Christmas dinner. Now that would have been fun.

★

I once came to see Jarvis Cocker here in Brid because one of my kids had a spare ticket. I went with them and I was quite disappointed because I was the only one that didn't get frisked on the way in.

★

I saw Mud here at the Spa, at the time when they had songs in the charts. After the concert I waited outside for them to come out. I was only young and it was getting quite late, so I had a double-edged sword decision to make. Should I wait and try and touch a pop star so I could brag to my mates at school, or should I go home before I got into trouble with my dad? In the end I did wait to touch Les Gray and I did show-off to my mates and I did get a rollicking from my dad.

★

In the middle of the seventies I went to see rock bands; belly full of beer, straight out of the pub, playing air guitar or banging imaginary drums. I tagged along to Bradford with some mates who were going to see Thin Lizzy at St George's Hall and then for a curry – I'd never been for a curry. I don't remember much about the gig, but I do remember the curry. The lads I went with had all been before and decided a place in a basement on Morley Street was the best. I don't think there was a menu. There certainly weren't any knives and forks. I recall the words 'madras', 'vindaloo' and 'meat and peas'. I had no idea what to ask for so I went for meat and peas and six chapattis. It was delicious and cost 30 pence. I never saw Thin Lizzy again, but when I went to Kashmir I knew what to ask for.

★

In the early 80s when Channel 4 was 'young and happening' they commissioned some fantastic documentary programmes. One of my favourites was a

series of thirteen films, seven years in the making by the traveller Jeremy Marre. It was called *Beats of the Heart* and looked at popular music from around the world. One week we were taken to hear the religious music of the Appalachian mountains, the next to listen to the shotguns and accordions of the marijuana regions of Colombia. To tie in with the series Channel 4 published a book filled with stories and some priceless images. One showed King Bhumibol of Thailand playing his saxophone like Stan Getz, another studied the wizened features of Nimrod Workman and his friend Hazel Dickens, two singers from the coal mining region on the Kentucky-Virginia borderland. An image that appealed to me most though was a photo of an Hungarian Gypsy fiddle player performing in a restaurant in Budapest. It seemed so romantic, cool and Bohemian, I could almost feel myself sitting at a table with a checked tablecloth and a candle in a bottle.

Call it fate, destiny, what you will, but just a couple of weeks after I was invited to Budapest by some German friends who knew a Pastor called Janosz Szel who ran a little Reformed Church in old Buda. Janosz took us to eat at his favourite restaurant, an ancient place in a badly lit area of town, that did, according to Janosz, 'the best carp soup in the world.' We booked a table for four, it had a red checked tablecloth with a candle melting a run of wax down the side of an empty 'Bulls Blood' bottle. We ordered the soup, it came in a basin as big as my gran's bread bowl. A red stew, filled with lumps of carp and bone. Janosz ladled powdered paprika onto it, so we did the same and dipped chunks of rough bread into it. The taste exploded on our buds.

A Gypsy violinist came and played at our table. I watched his fingers working the strings and studied his face. I thought, 'I know you!' Then the penny dropped. It was the same player whose photograph I had admired in my *Beats of the Heart* book just before I left to come here. All these phrases that people throw out like 'It's a small world' came to mean something to me at that moment. But the one that will stick is that phrase that people say when they're excited, 'My heart skipped a beat.' I came to know exactly what that means, that night in The Sipos restaurant in old Budapest.

<center>★</center>

I saw Tinariwen at WOMAD, a Tuareg band. I had lost track of Tuareg friends. After the show I hoped they would appear at the fence, the band. They did. It turned out they knew my friend Al-Housseini Intagart. The Tuaregs are such a close community. I gave them my card with my details and we are back in touch. I've visited three, four, five times since. That band brought me back to West Africa.

<center>★</center>

In Burkina Faso every year there are big festivals; craft in November, literature in the Summer and films in February. People come from all over Africa. I was in Burkina Faso. In this place there is an open stage like a Roman stadium, I was having a bite to eat. I saw this guy playing a plastic recorder. Then he started playing two recorders at the same time with two hands, both of them in his mouth. He was incredibly skilled, I thought, 'Gosh, that's amazing!' I asked him, 'Why don't you have a wooden recorder?' He said, 'I can't get them here.' I said, 'I will send you one.'

I sent him *all* my recorders, I even sent him my flute. He'd never seen a flute, he'd only heard of them. He stayed in touch a little bit. Now he's playing in America, he's a professional musician. I suppose I opened that door for him.

<center>★</center>

I travelled in Africa for ten weeks last year with my daughter. We went to a three day festival on the shores of Lake Malawi on my birthday, it was fantastic.

I have given up my job in a whole food shop and will be renting out my house to fund volunteering in Africa. I am ready for a change and I want to feel more involved.

<center>★</center>

I went to see *Madame Butterfly* with a group of friends from work. I'd never been to an opera before and didn't really know what to expect. Well, the performance was three hours long and I couldn't believe it, as I loved every minute. When I came out of the theatre my body was so full of emotion. Our motto of the night became, 'Unless you try something, you never know.'

<center>★</center>

I love Jimi Hendrix, so I headed over to Derby to a venue called Warehouse to see a Jimi Hendrix tribute band called Beautiful People. I found myself in conversation with these guys who were drinking and smoking weed that turned out to be the band. They told me that Hendrix's cousin, who is from Sweden, was at the gig and they introduced me to him. I couldn't believe it! At the very end the lead singer dedicated the last song to me, it was 'Foxy Lady'... how cool was that?!

★

I attended an American arts festival that I had always wanted to go to called the Burning Man Festival. It's built in the middle of the desert in a place called Black Rock City. It's a week long festival and I was asked to play there because I was known as a DJ. In order to get there I had to travel though the night. On arrival I discovered I would be playing on top of an Arts Car, which was a giant vehicle that looked like a bread van covered in neon lights. I got on top of the vehicle and the driver drove me to where there was an effigy of a giant burning man. It looked like something from the film *The Wicker Man*. I was told I was going to be playing on top of the car for an hour, but in the end I played for over five hours, all the time the giant burning man was throwing flames out. I was buzzing.

★

My material is quite political and social I suppose. I've just got a six track EP out called *Austerity*. I go to about five festivals a year. The best one was when I played the Milkmaid Folk Club Tent at the Cambridge Folk Festival. I got quite a good reception. At least I didn't get booed off.

This weekend I've come to see Joe Solo. I know him through Facebook. He does a lot of songs about the First World War. I've seen him before at Filey Folk Club. I'm an old punk rocker actually, there's not a lot of difference fundamentally between folk and punk. I used to have spiky blond hair and I've had a Mohican. I used to wear lime green skin-tight trousers, my family were horrified. My friends weren't too pleased either.

★

I know Duncan Chisholm who plays fiddle with Julie Fowlis. He was playing once in a village hall in the far north of Scotland. When his band got there, the support band was already on, so they were shown to a room at the back. Their rider was for sandwiches and beer. On a table was a crate of McEwans Export, a crate of Tennants lager and a big chocolate cake. They got stuck into it. The support band had finished. A man came rushing into the back room and very flustered said, 'Any of you's seen the raffle prizes?'

Peace Boats

Refuse to have a battle of wits
with an unarmed opponent

Only dead fish go with the flow

Be with your angel and become an angel

Your heart is the rhythm of your soul

Follow your heart, not your brain

Smile, laugh and live a great life

Life is the boat to happiness

Don't look for magic, it will find you

Float away and live your life with joy

If everyone did Anger Management

From the sparkling stars to the twisting waves,
I miss you darling Susie

Saturday
Stories We Tell Each Other

Fritz and his glamorous assistant Betty
Making Mates

D: I was singing in a club in Wylam in Northumberland, where I lived. I sang bawdy ballads or bog songs as they were called. I'd seen a girl come into the club the previous week with a friend, but this night she was on her own and so I invited her to sit with me. She was called Ann and we lived in the same small village but had never met before. We were married six months later in Prudhoe, also in Northumberland.

A: This is my version of how I met Dave. I went to a folk club in my village, I hadn't been there before, not sure why. I went with my sister and enjoyed it but we were nervous because we had to leave before the end and thought Dave would have some quip about us if we got up during his performance. So we waited till the end of a song and made a dash for the door without looking back. The next week I was supposed to be meeting a friend there but she didn't turn up. I think Dave took pity on me as I was on my own and came over to chat.

We were married the following July, a double wedding with my twin sister, who also married a Dave. The best man was called Dave too.

D: We've got two children, both have graduated from Cambridge. Our daughter is in Whitby this weekend at the Goth Festival. She went off to uni a folkie and came back a rock guitarist.

A: The best thing we ever did was buy a campervan, this was twelve years ago. We used to go to festivals with a tent and then put it up in the rain. One day Dave said, 'I'm fed up of this, we'll get a campervan.' The couple who live next door to us call us part-time neighbours.

When we were at Holmfirth Festival, Dave had a heart attack. It was all very frightening but people were so helpful. Dave ended up in an ambulance, then a stay in hospital. The first night I had to go back to the campervan, it was dark and I was frightened on my own but didn't tell Dave.

D: I had planned to steward here last year but after being unwell for quite a while I ended up having a triple heart bypass. The surgeon said to me, 'You think this is major surgery but it's a bit of plumbing, we do 600 a year.' This was at Newcastle Hospital. I was told, 'When you get out of here you must go for a walk every day.' I said, 'You must be joking, have you seen the hills outside my window!'

A: Dave and I celebrated our 25th wedding anniversary at Durham Folk Festival. In January we will be celebrating meeting in that folk club 40 years ago.

★

I was working at Don Valley Engineering. A new guy started called Neil and I had to show him the ropes. We

got talking and he asked me if I'd like to go to a Céilidh, I didn't have a clue what this entailed. Anyway, I said okay and myself and my wife went along with his wife and his friends. Two hours into being there, I'd gone to the bar and when I came back Neil and friends had disappeared. I asked Neil's wife where they were and the next thing, they all came out in Cotswold Morris outfits – dancing, whooping and waving sticks to Morris music.

I was a bit bemused but found it entertaining, the wife said, 'You ought to join them, you like acting the prat.' So I did and I stayed for two years.

★

My first experience of a festival was when I was eighteen. I went with Pete after meeting him three months before. This was to the Reading Rock Festival and will always have a special place in my heart as Pete asked me to marry him. I said, 'Only if you've got a ring.' Pete instantly reached for a pickled onion Monster Munch and there I was, at Reading, engaged with a ring smelling of pickled onion. We have now been married for twenty-three years. Sadly, my ring only survived three days.

When Pete and I met we were worlds away in our taste in music. He was the stereotypical Status Quo fan. Tight faded jeans with real holes and patches over the holes to mend them. The short Wrangler jacket, black or blue t-shirt, usually with Status Quo or Hawkwind on. A packet of Juicy Fruit chewing gum in the top pocket of the jacket. Not forgetting the very long straight hair. I, on the other hand, wore long velvet skirts and Indian silk shirts with beads and sequins on. Often to be seen in sandals, even during winter. A bell anklet on my right ankle, smelling

of patchouli oil or lemon grass, and long hair, sometimes the deep colour of purple or startling red, usually crimped in layers.

My passion was folk and World Music, and my aim at the age of seventeen was to go to Cambridge Folk Festival. This however produced a reaction of shock and horror. Pete told me that, as a couple, this wouldn't be happening. So, whilst still quietly enjoying the music I loved, I went to Quo concerts, Reading Rock Festival, Stonehenge and really enjoyed them. Pete introduced me to another world and even now my foot will tap when a Quo song comes on.

Whilst all this was happening there was a quiet revolution. We started to travel further afield and absorbed new experiences. After our twenty-second Cambridge Festival we have both grown in our appreciation of a number of music genres. Pete now wears jeans, beautiful jumpers, and has this year started using a man bag! My hair is short, though my love of velvet has stayed. I have grown away from patchouli oil to the relief of my mum who called it rotting bog water. Pete and I are still enjoying our journey through the music of the world.

★

I met my husband through a mutual friend and interest in folk music. We both had dad's who played double bass in various orchestras, so that got us talking. My husband's dad founded Wantage Orchestra in 1977 for the Queen's Jubilee celebrations. My own dad was a big part of the Grimsby Symphony Orchestra who regularly played in and around the Grimsby/Scunthorpe area.

★

I've always been influenced by different vibrations, and how they make you feel different ways. I met my partner, who had done a 'Soul Retrieval' at a Tipi village in Devon, and then we discovered Trance Dance – where you bring yourself to an ecstatic level through breathing. There was something called the 'Fire Breath', where you inhale vigorously to the sound of an earth drone, with bandanas over your eyes, so you have to think about what you're hearing and doing, and are completely concentrating on movement. We also learned about connecting to our ancestors and power animals and to dance to their rhythms.

★

Some of the music we play today we learned at the medieval festival at Kaltenberg Castle near Munich. We learned songs from Germans in costumes, complete with leather codpieces. We were all given a stein pot. We filled ours with tea for breakfast; a litre of tea, that's an awful lot of tea. The Germans filled theirs with beer, yes even at breakfast.

We gradually dropped the music for quite a long time as we needed to find something fresh that no one else was doing. So we became Fritz and his glamorous assistant Betty – offering thrills and spills and other such stuff, where we did stilt walking and fire blowing.

In those days we toured with our two children, Millie and Zeb, aged two and four. We had a nanny who toured with us doing 200 or 300 gigs a year. In the mid-nineties we had a six month stint with our act at a Dutch theme park in Japan. We each wore a sort of man-sized puppet which looked as though the puppets were carrying us on

their backs. We had them made in Japan and even had them adapted with a lever inside the costume to move the puppet's hands. We could pinch bums with them.

I'd been feeling unwell for a while so went off to the hospital with an interpreter. Six weeks previously the Japanese President had died, so the whole country closed down for two days. This left us with nothing to do at all – well, that's my excuse and I'm sticking to it. After the hospital tests the interpreter said very succinctly, 'You are probably pregnant.' So baby number three was made in Japan, he's called Jason. We finished the six month contract then headed back to the UK. Two years later we had our fourth baby, a girl, Carmina, so it was time to cut down the touring, and limit the gigs to about thirty per year.

If we'd known just how right we were going to be
Sharing Our Pasts

I stepped off the train at Paddington to leave Lincolnshire behind. Within a day I had realised what a big place London was and that I had to get a job. My friend told me that I ought to go to Carnaby Street. 'Just tell them you've done retail before,' she said. I stood at the end of Carnaby Street and thought, well, what do I want to sell? I saw that there were three shoe shops. I'll sell shoes then. I went into a shop where there was a young lad my age. I made eye contact and asked about a job. He told me that they didn't have anything but perhaps Ravells next door would. He told me to say that I had done shoe selling in Scunthorpe. I got a job there. It was at the end of 1965 and everything was happening in London and a lot of it in Carnaby Street. I worked there for about nine months. Musicians and music biz people were coming in and out all day long. Mark Bolan was always in there.

I met a guy called Johnny Hayes who was a DJ for Radio Caroline. He had friends who were starting a harmony group called Pyramid – a three piece vocal harmony with a backing group. I joined them. Round about this time a group called the Ethnic Shuffle Orchestra had just changed their name to Fairport Convention. Joe Boyd, their manager and producer, spotted me with Pyramid and took me to meet the band. They were in the

studio recording their first single when I said hello. I joined and stayed for two years. So I guess I must have passed the audition.

<p style="text-align:center">★</p>

I went to university in Essex when there were Chilean students there in exile from Pinochet's regime. I'd heard about the protest when Allende supporters had been rounded up and locked in a football stadium, including Victor Jara, a folk singer who was married to an English dancer. His records were all the rage with the students. He had a spellbinding, rich voice. They cut his hands off and killed him. It was a symbolic act. His music had the power to foster the revolution, to reach the peasants as well as the middle class.

All this aroused an interest in South American music, so I decided to spend a year and a half in South America. I had my first job in Patagonia at a private boarding school. It was a beautiful place with lakes and mountains, but I had very little time off. Someone lent me two records. One was by the Argentinean Mercedes Sosa, with her very deep voice, and the other was by Violeta Parra from Chile. I played them over and over and they kind of consoled me.

Quite often in South America you come across *guitarradas*. They're in a café, a room, a private house. They pass a guitar round and sing. The best was in Argentina in a town of coloured mountains, called Humahuaca. The mountains were striped; pink, yellow, tawny and cream. When the light shone it lit up those mountains. People stayed for hours, I wished I could stay forever. I played guitar and mandolin. I used to sing our repertoire, 'Wild Mountain Thyme' and 'Psalm 23 Crimond'. I don't know what they thought.

I have this vision of the men at an Inca festival at Lake

Titicaca – they danced like grasshoppers, up and down, rocking. That's when I heard the haunting Andean flute and a charango, a stringed instrument made from the back of an armadillo. It's tuned in a minor key and sounds like its shredding the sound, a sort of tremolo effect. It has a longing about it.

<p style="text-align:center">★</p>

When I was in Singapore in the early 60s, I had to go to the Armah's market to get any records. The 'Armah' was our Indian nanny, without her I would never have known where to buy records in Singapore as there wasn't much Western music then.

I went to an English speaking school called St Johns. All the kids who attended had parents stationed in the Services in Singapore – RAF, Navy and the Army from Britain, Australia, USA and New Zealand. My father was an air traffic controller in the RAF stationed at RAF Tengha, I remember we lived on Meteor Road – at the time all the roads were named after British aircraft.

Lots of bands visited Singapore – the Rolling Stones will be one gig I will never forget. When we came out there were loads of riot police, I was gobsmacked, all we'd been doing in the gig was jumping up and down clapping, cheering and a bit of screaming. They weren't used to it.

The next day our headmaster went mad, he held up the *Singapore Times* and said the English were dreadful. He was English but the press had only photographed Europeans; none of the Chinese, Malays or Indian people who were at the concert were photographed. There were no Singaporean females there though, as women from Singapore weren't let out at the time.

Our family went to Penang Island (Malaysia) where we were issued with guns. At first in Penang we used to watch the USA version of *Top of the Pops* until the Sultan of Johor banned the programme because the dancing was too risqué.

<div align="center">★</div>

My mum and dad were managers of a caravan site and my mum performed through the summer in a dusty old bingo hall at the back of the site. It was the first time I wore make-up and it made me feel really grown up. We sang along to backing tracks, which these days I would never condone, but back then it seemed more acceptable – well, it was the early nineties! I was never that fussed about playing an instrument but plonked about on my mum's keyboard a little bit.

When I was thirteen my mum and dad picked me up from school. They were late as usual, they were always late... but I knew they had gone to buy a new kitchen so I thought they would arrive soon. On the back seat of the car was a box... an instrument case... turns out that the saxophone shop is on the way to the kitchen shop and they accidentally ended up with a tenor saxophone. Mum would have to wait for her kitchen. After all, they had formed a band with an uncle of mine and they needed a sax player. As it is hard finding sax players – they thought it'd be easier to just make one.

Through my teens, I didn't really take to my sax and played it out of some kind of duty to my parents, but when I was fifteen I joined a punk ska band who already had a UK tour booked. After years of protesting that you can't play sax in a punk band, it was the *only* reason I was in a

punk band. Fast forward a few years of tours and many, many, many gigs and sleeping on floors, I seemed to have drifted almost seamlessly into a more World Music roots and alternative types of music. I hadn't picked up my sax for a few years and over a pint one night a friend of mine invited me to guest at a gig he was playing the following Saturday with his salsa samba band. I arrived at the gig, which I thought was going to be a small affair, but it turned out to be a huge sold out salsa event in the Town Hall in Lancaster. My friend had forgotten to tell the rest of the band that I was coming so they looked a little disgruntled. The leader of the band told me to go get tuned up and handed me some sheets of music. I waved at him, 'No point giving me those, I can't read them! I can only play by ear.' He looked even more disgruntled but said he would still give me a go and they would get started and nod when he wanted me to come in. So, in front of 200 people he nodded me on stage, not in a build up with enough time to figure the tune out, but he brought me in on a solo. Luckily, very luckily, I was feeling the vibe that night and it was a success. I opened my eyes just long enough to see the sheer relief on the band's faces.

A year later they played Musicport on the main stage. It's funny really because even though I have a role behind the scenes at Musicport, it seemed to surprise everyone that I appeared on the main stage as a guest with the salsa band. It was great having the opportunity to experience the festival from another point of view and it made me realise just how important Musicport is to the wider community and how much it is really a part of all of us who come here every autumn. Many people who are involved in music bridge that gap between performers,

organisers, stewards and punters and I think that is part of the magic of the festival.

<center>★</center>

I volunteer for Love Zimbabwe, which is a charity and trading company run by my wife Martha that undertakes various community projects. I came up with the idea of writing a song about the problems in Zimbabwe and to record it somehow, somewhere and sell it to raise money for the charity. I asked Martha for a phrase in Shona that means something like 'How do we survive?' that I could use as hook. She came up with 'Torara Ma Sei'. Around this I wrote a song.

I took the song to Zimbabwe and sung it to the people in Martha's family village, Dombashawa. We filmed the song with thirteen villagers dancing along in the background with me playing guitar in front of them. It was exactly what I'd envisaged in my mind.

During that trip we went to a township called Norton, which is where Oliver Mtukudzi has a community centre/ restaurant and where he also lives. On our arrival we learned that on the very same day there was a musical festival happening at Oliver's place. The line-up included Sam Mtukudzi, Oliver's son, who at that time was only eighteen. He was playing with a group called AY Band, all the musicians were twenty-one or under and fantastic players.

After the concert we made our way backstage to thank Sam for his wonderful set. We introduced ourselves and sat round a big table, Martha and I with Sam and his band. In conversation I told Sam that I'd written this song about the situation in Zimbabwe and I'd love him to hear it

sometime. Sam said, 'How about now?' I mumbled something about not having my guitar but he said to just sing it. So I sang the first two verses, and he must have found something in it he liked because he invited us to visit his father's studio the following day.

The next day we set off following Sam's directions and arrived on the outskirts of Norton at a newly built bungalow. Sam greeted us at the gate and showed us to the annex which made up the 48-track recording studio where his father 'Tuku' recorded all of his international releases. I remarked on the size of the house and how beautifully it had been designed. Sam told me that the last house had been destroyed because of the lyrical content of Tuku's recent releases.

We set about putting down the backing track with the whole of his wonderfully adept band. Initially I had tried to jam along with a guitar but they soon lost me with intricate African rhythms and jazz. We spent about four hours getting the backing track spot on, with Sam putting everything down on computer as well as playing guitar and adding a sinuous saxophone solo. Just as we'd compiled everything, the electricity cut out – a common occurrence in Zimbabwe. We said our farewells, thanking everyone, with Sam promising to send me the track by email.

Soon after, we returned back to the UK and true to his word, Sam mailed the track that week. Martha and I had friends in Aberystwyth with a recording studio so we took it there and I added my vocal. We put the song on the Love Zimbabwe website to download for a small fee, which now has raised a few funds for the charity.

Sadly in 2010 Sam was travelling back from the airport to Norton to see his father, when his car was hit full-on

by a truck and he died instantly, one week before his twentieth birthday.

<center>★</center>

I started playing the trumpet when I was ten. I played in the school orchestra and also the local youth orchestra. My entire social life throughout my teens was all about music. It was a lovely hobby, but I had no aspirations to be a professional musician. At uni I auditioned for the orchestra but didn't get in. Now the trumpet is not a very satisfying instrument to play on your own, so I got into a cycle of not playing and when I did pick it up to play it sounded shit. I became disillusioned. In 1993, in an attempt to reinvent myself, I came to Leeds and thought 'I'll not tell anybody that I used to play trumpet'. Then within six months a friend started telling people, next thing, someone gave me a trumpet. I was invited to play at the Slaithwaite Moonrakers festival and I then met up with the street band The Peace Artists and I was off again. In 1996 Chumbawamba were looking for a trumpet player, ideally a woman who could also sing and I got the job. Within the space of a year I found myself part of a hit record that topped the charts all over the world.

<center>★</center>

I started learning piano at seven, but by the time I was fourteen I realised I would never be a concert pianist. I carried on through though and played stuff that Jolson had sung and second world war dance band stuff. I had to leave the piano when I went to sea. It was there though that I encountered a different world of music. The crew were mostly Gujarati seamen. In relaxing time they would make

little plays and sing. I'm sure the songs were about chickens and farmyards and pinching eggs but they were sung with great enthusiasm and they fashioned their own percussion instruments out of catering pack tomatoes and marmalade tins.

★

When I got to Leeds University, I was there to study economics, but there was something else as well. I knew all about the reputation Leeds had for putting on fantastic music. This was where The Who had recorded one of the greatest live albums ever. I don't know what made me do it, because I'm shy really and not good at talking to people I don't know, well I was back then. I went up to the Student Union gig office and marched up to Steve Henderson's desk. I told him that when he had done with it, I wanted his job. And I got his job, it was an inexplicable moment of uncharacteristic impulse, but everything I've ever done since and all of my travels through the world of music flow from that one moment. The thought of that still frightens me to this day.

★

I lived in the Scottish town of Troon, a one-horse town where nothing much happened. I had a Saturday job in the Italian café, the family running it were called Toggs, short for Togneri. Mrs Toggs would sing in Italian in the morning while I was cooking the bacon. She had a picture of herself as a young woman on the side, looking like a film star.

 I was fifteen when Radio Scotland pirate radio parked off the coast of Troon. It was at the time of Radio

Caroline/Radio Luxembourg. The DJs came into the Italian café for breakfast, and it was a huge buzz to serve those DJs.

I went thirty-five years later and the café was still there with exactly the same deco. They still had the tin I used to keep my tips in.

<div align="center">★</div>

I was seventeen, squatting in London and working as a street cleaner. I was a massive fan of Diana Ross, loved the woman's voice and I heard that she was in a film called *Lady Sings The Blues*. I went to see it at Shepherds Bush and I was blown away by what I saw. I'd never heard of Billie Holiday before then. Next morning I went straight up to Portobello market and bought every Billie Holiday LP I could find, *Lady in Satin* was one of them. When I started singing and recording, I wanted to do a Billie Holiday cover on every album I did. We put 'Nobody's Business' on one, 'Good Morning Heartache' on another, then 'Don't Explain'. We put a good old band together back in Dublin and did a full Billie Holiday review. We toured it to Australia, New Zealand, Scandinavia and then did a double CD of it live. They say Billie Holiday never sang the same way twice. I believe that, the way she sings goes straight to your heart. I have a very deep empathy for that stuff. It's what makes me want to sing and why I end up at World Music festivals in Whitby and Bridlington.

<div align="center">★</div>

My first introduction to Nina Simone was at a gig in Poland. I had been asked to play percussion in her band as the usual member had pulled out at the last minute. I

came on stage and was introduced to the audience as her new percussionist. Nina was playing the piano at the time and didn't even look up to greet me and her first words were to me, 'You'd better be able to play!'

I felt really under pressure. The performance went very well and despite the harsh initial remarks she wanted me on board with the band for the remainder of the tour, which incorporated some amazing gigs, including one for Nelson Mandela. I was very honoured and very excited at the prospect. Then she died. That was a real shame.

★

When I was twenty-nine I decided I wanted to travel around the world. I'd made up four compilation cassettes to take with me and then a friend gave me a tape which had 'World Music' written on it. When I saw the title, I presumed it was a compilation he'd made for my 'world' tour, so I made a bit of extra room in my bag for it.

I took with me a personal stereo cassette player but I didn't have space for many batteries, so I saved up what little power I had for special moments. One day when I was in Nepal I'd been out walking for twelve hours and when I got back I was feeling quite low. I decided to treat myself to some music and pulled out my friend's 'World Music' tape. I tucked myself in bed, laid back and pressed play. I was hoping for something familiar to comfort me, but when it played I couldn't believe it was literally World Music. I have to admit that I cried that night. What's worst is that later on in that trip I actually taped over it. I prickle under the armpits with shame just thinking about that now.

So, my first encounter with World Music wasn't very

successful, but sometimes we don't always instantly connect with music, we sometimes have to listen to it more than once, especially when it's different. Of course I have shelves full of music from all around the world now.

<p style="text-align:center">★</p>

I joined the merchant navy as an apprentice, but broke my indentures to leave and ended up on building sites. I did two trips to Australia and one to New Zealand. It would be 1965 and 66, I know this because when England won the World Cup I was in the middle of the Indian Ocean. My cabin mate was Fraser, a Scottish singer with a lovely clear voice, he sang 'MacPherson's Rant'. We sang together on board, I had built a repertoire from a combination of word of mouth and three folk records: one by The Watersons; a compilation called *The Iron Muse*; and an album of sea songs called *Farewell Nancy*. My favourite one was one I learned from my mother called 'The Rogue'. I still sing it now. 'Listen and I'll tell you what the rogie he said to me.'

<p style="text-align:center">★</p>

I used to run a CD stall in the days when CDs used to sell quite well. I'd mainly sell specialist interest stuff; World Music, funk, blues, folk and quite a lot of reggae. One of my regular pitches was at Merton Abbey Mills Market in South Wimbledon. It's by the river with a big water wheel, it's where Liberty's used to do their weaving. Because it was such a lovely spot, we used to get all sorts of people coming down for a nice Sunday afternoon out.

One day I saw this guy looking through the CDs; quite tubby, long grey hair, balding on top, very much like a lot of guys who came to the stall. When he looked up I

recognised him as Peter Green. I said to him, 'I think I might know who you are.' Some well known people can be a bit reticent when faced with that kind of approach, but he was happy to talk. I told him straight out that I considered him to be the best blues guitar player Britain had ever had. Anything that came after his Fleetwood Mac was just confection. He just mumbled, 'Yeah, yeah, but I wont be satisfied until I've learnt how to play the guitar properly.' He said that he'd never had any formal training and he wanted to play classical guitar and read music. I told him that I really didn't think that would be necessary.

He was living in the Putney area at the time, which wasn't far from the market so I started to see him on a regular basis and we used to get talking. He'd buy African and Asian music mainly, and the most eclectic kind too, certainly no blues or rock 'n' roll. I had a CD player on the stall and he'd say that he was looking for something with a particular kind of sound, so I'd pull stuff out that I thought would match, put it in the player and he'd say if he liked it or not.

He'd not been back playing long at this time, he was just coming back from his long exile. I remember reading stories about him being in quite a bad way in his wilderness years, growing his fingernails really long so he couldn't even think about playing the guitar. We did occasionally talk about his condition. He told me that he still had flashbacks from LSD trips he had over 30 years previously. He said sometimes it's hard to cope.

★

I used to work on an early evening magazine television programme that went out after the regional news. It was

a mixture of all sorts; fashion, food, gardening, local culture and it was very popular, so much so that we entertained live guests promoting books, films, and CDs. By far the funniest incident involved Steve Harley, lead singer with erstwhile chart toppers Cockney Rebel. He was sitting in the green room, watching old footage of his heydays, when the make-up artist came to see him. 'Will you require make-up Mr Harley?' she politely asked. 'I'm a fuckin' rock star darling, want do you think?' he replied.

<div align="center">★</div>

Fifteen years ago I wrote a jazz instrumental piece inspired by a saxophone line I'd heard in a Supertramp song. In my growing up years I had been a big fan of Supertramp, especially the saxophone sound of John Helliwell. A few years ago an email came to me from a guy who wanted to buy one of my CDs – the guy I sent a disc to was called John Helliwell, the same John Helliwell believe it or not. We have become friends. He recently came to play with me in my hometown pub. We played the piece he inspired all those years ago. It's called 'If we'd known just how right we were going to be'.

<div align="center">★</div>

There was a record we used to play while waiting for our dad and uncles to come back from the pub on Christmas Eve. Songs like 'Danny Boy', 'Ugly Duckling', 'Little Donkey', 'Deck of Cards' and 'Little White Bull'. The folk would come back and they would all sing.

★

The first record I bought with my own money was 'Mickey' by Toni Basil. The man in the shop had a good laugh at me as he handed it over. For him it was a old man's tune, a singalong. I bought it because it was on the telly and the radio all the time. The video appealed to me because it featured cheerleaders in it, and I wanted to be one of them. It was a fun song and I could sing along to it.

★

My dad used to play a lot of Queen. I nicked the *Greatest Hits* album from him and was instantly hooked. I liked the harmonies and the screaming they got out of the guitar, the melodies were so memorable. I had to have a guitar. My granddad got hold of one for me from a second hand shop. It was so knackered I couldn't tell what make it was. I wanted guitar lessons, but my dad could not afford them so I used to just listen to Queen records in my bedroom and try and work out how Brian May was getting those sounds. I didn't have much chance of emulating him though, I didn't even know how to tune it up.

★

In 1963 I lived in Montpelier (Bristol) just next to St Pauls. It was the fist time I ever heard African Caribbean and African music. We didn't call it reggae then but blue beat. They were just jamming nights. They were never advertised events and many weren't organised in an established fashion. It was just word of mouth. You could get a pint of beer and a goat curry for next to nothing. I was lucky to get in, I had some black mates who took me

in a couple of times, then after that it was okay to go on my own. That was all pre-Beatles. Before The Beatles a top ranking Friday or Saturday would always be blues. The whole feel of the music changed with The Beatles, they were pure rock 'n' roll.

★

When I was about eight years old I heard of a band called The Beatles and that all the teenage girls screamed when they saw them. I had never seen a picture of them and so assumed they were actual giant sized singing insects that were causing all the hysteria.

★

When I was working in the Co-op office in Darlington at the age of seventeen there was to be a bus trip one night to see a band in the charts. Being young and naïve I didn't believe that it was a concert by The Beatles at Stockton. Yep, when we got to the Globe Theatre, sure enough it was The Beatles with Mary Wells as support. I still have the programme at home. It might be worth a few quid now.

★

My first gig was at the Odeon in Stockton-on-Tees. I'd be nineteen. In those days you had a lot of chart acts on the same bill. The one in Stockton had Dave Dee, Dozy, Beaky, Mick and Titch, they did their hits 'Hold Tight' and one that was something like 'Legend of Xanadu', it had a lot of whip sounds in it which they made with swishing capes they were wearing. The Walker Brothers were on doing 'Make it Easy on Yourself' and 'The Sun Ain't Gonna

Shine Anymore' but the top of the bill was Ike and Tina Turner with the Ikettes – 'River Deep-Mountain High', the hit of the day. I don't think I appreciated how great these musicians were at the time. I was young and these were the bands that were around.

★

As a teenager I lived in High Wycombe. We used to sneak out without our parents knowing. Although we were underage we managed to slip in to see Ike and Tina Turner, then another time we saw Wayne Fontana and the Mindbenders.

★

I used to go to a dance on a Monday at Pontefract Town Hall. They played soul and it was mostly the lads who used to dance. They'd put talc down on the floor so they could slip and slide with their dance moves. They'd be wearing wide-toed crepe-soled shoes and Oxford bags. I remember a group used to go to Wigan to a soul dance too, but my mum wouldn't let me go.

★

I was brought up in the Staffordshire Moorlands with a traditional Methodist background. I knew my John Wesley from my Isaac Watts, but my musical enlightenment of that kind pretty much stopped there. At fifteen I moved to London, my grandfather thought this akin to being transported, which, in more ways than he could have imagined, it was. In an old turntable shed at the bottom of Chalk Farm Road I discovered a new world of music. Jeff Dexter's Sunday afternoon implosion not only opened

my ears to the new psychedelic era, but also tuned me into things that would have me believe that my fifteen years life experience thus far had been based on a myth. Apparently according to the graffiti on a lavatory wall there 'Clapton was God'. I wasn't entirely convinced. I then fast forwarded through Pink Floyd, Man, Deep Purple and Focus, again I wasn't convinced that I needed anymore chakras opening or that if I stared long enough at certain LP covers I would see something deeply mysterious appear, but I stuck with the journey. Eventually ennui was blown away at a small folk club in Swansea, where I discovered that real history, storytelling and myth could be found by listening to a man with a finger in his ear. There my love affair with traditional folk music from around the world began.

★

My Auntie Val would be eighteen-years-old and lived with Gran. I thought she was great. She wore long hippie flowery frocks and Biba make-up. I would sneak into her room and try it on; I am still a Biba fan now. I'm ten years younger than my Auntie Val, who's a bit of a musical heroine of mine. She went to the Isle of Wight music festival to see Jimi Hendrix on a scooter. When she came back my gran was appalled to discover that she'd only taken one clean pair of knickers with her.

She came to live with us when she was about twenty-six. She brought a stash of records with her that I think she'd been given by an old boyfriend. They were all old soul and Tamla Motown records – Four Tops and Martha Reeves and the Vandellas, all that kind of thing. It was the first music that I really took to. When everyone else was

out on a Saturday, I would play them really loud. I just kept turning up the volume. I'd dance round the lounge to them.

My Auntie Val gave me all those records eventually, I suppose the boyfriend didn't mean that much to her anymore.

<p align="center">★</p>

Punk made a big impact on me. I identified with the way of life, the politics, anti-Nazi League, music, the anger, the excitement, being involved, going to gigs, festivals, and doing our best to get off our faces. To be honest I was often off my face. A friend reminded me not long ago about how we went to Stonehenge in an old transit van but I could hardly remember.

We used to go all over to watch punk bands. I remember Barbarella's at Birmingham in the 1970s. It was 50p to get in. I nearly saw the Sex Pistols there. My mates said The Spots were on so I didn't bother going, not realising the Sex Pistols were going under the name of The Spots. I also loved reggae music, especially Bob Marley.

<p align="center">★</p>

My hair is plastered to my head. A warm mist of condensation hangs in the air and looking up I can see prisms of colour, floating mini-rainbows in the hall made clammy and close by the sweat and breath of hundreds of bodies jumping up and down as one.

Awestruck by the noise and emotion, I look out across the mass of soaked heads to the band onstage. Up on my friend's shoulders, I feel I can reach out and touch Joe Strummer. Fingers into creases of soft black leather, t-shirt

underneath wet with sweat, back muscles flexing. All of us breathing and sweating into the same air. Strummer's sweat condensing and falling onto my hair.

We came from Hull on a minibus with some others from school, then dived into 'El Min', a friend's treacherous minivan with a slippery clutch – which is not what you want on a frosted January night – and headed to the Greyhound for a few ciders before coming back to the Spa for nine. They were on stage by twenty past.

London is calling the Wrong 'Em Boyo, and Tommy Gun might lead to some Death or Glory… and I have never felt exhilaration like this. Before tonight, I didn't even know what a gig looked like, and even while feeling that, I know that nothing can ever match this. The Clash, my first gig. No dipping a toe in the water for me. Head in the stars more like.

The crowd before me parts and two lads face one another in a space that, only seconds ago, was filled with jumping figures. They square up to each other, shoulders tense, arms held rigid across their bodies. I can see only one face, ugly and twisted. Looks like he's snarling. The crowd feels the fear. Then, one of the lads glances at Joe on the stage, telling us to Clampdown. There's a nod, and in reply he gets a shrug of the shoulders. The crowd closes around them and is as one again. Finished as quickly as it started.

Afterwards, we're carried outside on a tide of bodies which flows, steaming into the freezing cold of an east coast night, shouting, hugging and trying, but failing to find the words for what we've seen.

★

Me and the mates travelled thirty miles to a Jethro Tull gig through fog like pea soup. During the concert Ian Anderson was playing a quieter piece of music and you know when it's quiet, you tend to shut up. Well there were lots of these rowdy, loud teenagers making a row at the front. Ian Anderson stopped playing and called them a load of wankers. Everyone went quiet, I think we were all a bit shocked.

★

When I started playing semi-professional gigs I would get a bit over excited. As front man in Fred's Angels, at a New Year's gig I leapt into the audience leaving the punters on the floor whilst I carried on playing the ukulele on my back.

★

I always laugh that there should be an historic blue plaque on the wall of my old semi in Normanton where I set up my own little recording studio in the basement. I had tinkered about with recording since I was a kid, it was all I can ever remember doing. From about 1980 onwards, Black Lace started coming. They had once been a full band who had represented Britain in the Eurovision Song Contest. It was the year all the communications went down, so they were never seen and their song was a very minor hit. By the time I met them they were as poor as church mice and wanted me to record some backing tapes so that they could go out on the Working Men's Club circuit. Their manager went to Spain on his holidays and came back with a song he'd heard in the clubs and discos there. It was called 'Superman'. He said, 'Do us a version

of this, it'll be a big hit!' We all said, 'Yeah! Fuck Off!' And of course it was a big hit. Then they wanted to do 'Agadoo' and of course that was a big hit too and was later voted the world's worst record.

We moved the studio to Castleford, a place called Woodlands and that took on a life of its own. I bought expensive pieces of equipment, thinking, 'I'll never pay this off', but I did. ITV recorded a lot of stuff there with us and then Chumbawamba started to come. In 1997 we recorded 'Tubthumping' there, never thinking for one minute that we would have a massive hit on our hands. All we were trying to do was find another big song for the live show. They already had one called 'I Can't Hear You Because Your Mouth's Full of Shit' and we wanted another of them. It first had the refrain 'Rule Britannia, Britannia rules the waves' that was changed at the last minute to 'I get knocked down, but I get up again'.

The only problem with the Woodlands studio was that it was opposite a dripping factory and when they were rendering the bones and the wind was in the wrong direction, it didn't half stink.

<div align="center">★</div>

My first experience of Free Partying was on a beach out near Cromer in Norfolk. I was meeting up with my mates, they had a sound system and we were listening to old school songs like 'Firestarter' by The Prodigy, and drum n bass. Most people were hammered but I wasn't into all that, I was a good boy actually, my mind was open to new experiences but I wasn't into breaking it. What did it for me was the kicking sounds and my display using the fire toys I used to make. I'd make them with wood and washing line then set fire to them. The party went on all night.

★

When I was 10 years old I lived in the Virgin Islands, St Thomas. They had amazing carnivals there with steel drum bands and giant stilt walkers with long flowing pants. The British had outlawed the local music on the islands as they said that the people used it to joke about the British. This led to the islanders collecting the 44-gallon metal drums that used to get washed up onto the shore, then carving notes into them to create their steel drum instruments.

★

About six or seven years ago, when I was eight, my dad came home from the pub, he was a bit drunk and singing 'I Bet You Look Good On The Dancefloor'. The song was unfamiliar to me, but then I found out it was by a band called The Arctic Monkeys. I instantly became a big fan and have been ever since. As I got older, I started liking similar music to this and developed a favourite genre.

To welcome kings into their palaces
Formative Experiences

I am trying to let go from holding on, trying to find my balance. I am being sung to. All the family, neighbours, friends, anybody in the street is singing and clapping. We were brought up being sung to.

> Kasimama Deh! Deh!
> Deh! Deh! Deh!
> Kasimama Deh! Deh!

Back home we didn't have a telly at first, then we got a black and white one. I saw old Bollywood films from India; I saw the singer Umm Kulthum, the great Egyptian who always sang with her silk scarf; I saw Issa Matona the Zanzibari singer and I realised for the first time that some people did singing as a job. Before then I'd assumed that everybody danced and sang.

★

Our group is a collaboration of Scottish melodies and West African rhythms. Our music follows the trade winds, the flight of the swallow: here in summer, flies to West Africa in winter.

I grew up following street music in Freetown, Sierra Leone. I used to live in Clonakilty, in West Cork. I love

Ireland, their alpha rhythm is coherent with their cardio rhythm – the Irish are wholesome people who communicate soulfully.

You see, music is a people's art. It is folk culture. Where I was born, my mother was a dancer, singer, my brother was a singer, painter... At eleven, I had my own group.

I've travelled the world following the music as an innocent child. I've seen a three-legged horse race in Bhutan, where nobody wins. I've seen a frog that can sing and a pig that can dance and a dog that died for its master. Music is the source of life, let music be the healer of mother nature and mother nature will take care of all the artistic folk. Now Bridlington is buzzing with the vibration of music.

<p style="text-align:center">★</p>

After my mother had put us to bed she used to play the piano. I could hear it through the house as I was drifting off to sleep. When my daughter was small she used to wake up early and play the piano.

<p style="text-align:center">★</p>

From being a child I always loved Ladakh music. It is played with flutes and drums and is used to welcome kings into their palaces and lamas who are visiting. My sister used to sing Ladakh music. It always has a good memory for me.

<p style="text-align:center">★</p>

My father is from Bangladesh. He came to this country in the 60s and rooted in Glasgow where he met and married my mum, a true Glaswegian. My early music came from the Pakistani records that my dad used to play, with

some Indian songs. Dad and Mum played some Western music too – Shirley Bassey, Nat King Cole.

I loved music but the only programme in Scotland with Asian music at that time was BBC2 on a Sunday morning. It was in black and white. They played traditional instruments like the sitar and tabla and sang songs. We also watched Indian films whenever we could – for the music.

<div align="center">★</div>

When I was little, my dad used to play guitar for me and my sister. He played folk songs and I remember weeping whenever he played 'Clementine'.

<div align="center">★</div>

We were that poor we couldn't afford a radiogram, so my dad said the only way we were going to get one was to build one. So he went looking for some wood. On his journey he met this man who told him he made things and that he had some wood for him. The next day the man delivered the wood; it was a coffin. My dad cut the wood into the shape of a radiogram, which was basically a cabinet for a radio/record player, it had four black legs with little gold feet on the bottom and he got hold of some trim and painted it all black. He was very proud of it. He christened it with the Frank Ifield song 'I Remember You'.

<div align="center">★</div>

I grew up in a non-musical household. We had a huge sideboard with a radiogram in it but it was never used. I don't remember hearing any music and no instruments were played. My father won salesman of the year and he won a record player, so the radiogram sideboard was

removed from the house but the record player still remained dormant and unused.

★

My father died when I was young and my teenage years were full of angst. I took comfort from playing my guitar and singing sad love songs. I now use music in my teaching of refugee children, I teach them to play guitar. I also play mandolin and violin in church and even though I am out of my comfort zone, I now enjoy playing guitar and singing at open mike nights.

★

I am a very private man, I don't readily show my emotions. Some say I'm quite a hard person because of this, but music is very special as it can move me internally, trigger something deep inside, lift me and connect with a different level. My son used to be a lighting technician and worked on the show *Joseph and the Amazing Technicolour Dreamcoat*. This was his last ever show. He was killed in a car accident ten years in March 2012. Whenever I hear the song 'Any Dream Will Do' it stirs up the memories of my son from deep within and tears begin to flow. We played it at his funeral but now we can hear the song and it evokes happy feelings, emotions and memories. Music is a powerful medium.

★

My father played the piano, we used to watch *Top of the Pops* and then he would play what he had heard for me. He couldn't read music, just did it all by ear.

★

I heard this strange music blurting out from a record played which was placed on a stall at the outside market in Rotherham. There were albums hung up with pegs on a washing line. The sound I'd heard was Jimi Hendrix's *Are You Experienced?* I paid two shillings and six pence for it. The man who ran that stall went on to open a shop called The Sound of Music which was in Rotherham for over 30 years.

★

As a toddler, about two or three, I was addicted to Verdi's *Rigoletto* opera. I had me own wind up gramophone and put the 78s on all the time. At four or five, I hijacked the family's trad. jazz 78s for my gramophone.

Lonnie Donegan's 'Diggin' My Potatoes' got me into skiffle. I flirted very briefly with pop music and actually had a proper record player but I didn't like the music available on vinyl at the time. Not until I heard The Dubliners' 'Seven Drunken Nights'.

★

I was the oldest child at home so my early music inspirations were from my dad. He listened to classical music – Brahms and Mozart, he thought Radio 3 was too commercial.

★

I work with children with profound learning difficulties, including visual and hearing impairment, and physical disability. Ages ago the BBC had a series called *Opera Box*, which presented cartoon-style snippets for children. Once

they were presenting *Rigoletto*. I was with a seven-year-old girl and watched how she liked the music. When the music became dark and menacing she started crying, and when that stopped and the music lightened up and was joyful, she smiled and laughed.

★

I used to be on heroin and when I was getting off it, it was a really heavy time for me. I was making sequences on a Yamaha RM1X, like really hypnotic drones that went on for ages and ages. I had recently created one and so I put my headphones on to have a listen through. I was laid on my bed with the bedside light on but I must have been really tired and fell straight to sleep. I felt myself float totally out of the top of my head and out of my body. I opened my eyes and I could see the bed-sit exactly like it usually was, completely normal apart from there was a jungle snake sat on my chest. It was thin, coloured green and white with red around its eyes, just sitting there waiting for me in the astral. It struck out and bit me on the face. I tried to protect myself with my hands but to no avail. I immediately snapped back into this reality.

Embryonic journey tape
Musical Passions

A piece of music, two and a half minutes of music, possesses such crystalline beauty and intricacy that it's transcendent. I'm fourteen at the time and I probably don't know what the word transcendent means but hindsight provides that. But even at that age, perhaps especially at that age, you can appreciate the impact of a truly great piece of music.

Rochester market was a pretty unprepossessing place, – a few cheap clothes stalls and bric-a-brac. But it did have a music stall. At the time I was a fan of Pink Floyd and you know how it is when you are a teenager, things are obsessions. I had to have everything there was by Pink Floyd. I pick up a record cover from the cardboard boxes, I'm drawn to it. Perhaps because it's got psychedelic naked figures. It's a soundtrack album with two tracks by Pink Floyd that I have got to have so I carefully hand over my 18 shillings or however much it cost.

When the needle hits the first track, I hear the first notes of that two and a half minutes of music. The fluid notes of a guitar come out of the speakers. I've never found anything like it before. Two and a half minutes of 'Dark Star' by the Grateful Dead. Forty years later I still listen. I still get a tingle when I go to the Grateful Dead to listen to the jam of the week and I see those words, 'Dark Star'.

★

The Island of Zanzibar, my native land, has always felt mystical, full of spices and songs. On one particular day at Sauti za Busara Festival, there she was standing in front of me, the barefooted diva, Bi Kidude, singing like the powerful soul that she truly is; the healer, the storyteller. The jewel once again has touched my spirit. No one knows how old she is but rumour has is that she is between 95 and 105, singing since the age of nine.

★

The turning point in my life was when I saw Ani DiFranco. Her stage presence, the control she had over the audience. She was only five foot tall, the guitar she played was larger than her, the energy she put out, the focus on one note sometimes more, that memory stayed with me. If I had to describe her in one word that would be easy: passion. That's what you get from seeing her, she made me think you can't put that into words. I wanted to put this into music, so passion's the thing I want to show.

★

I have a friend called Buzz who lives in Glastonbury. He's in his 60s and an original hippy. He started making me tapes with colourful pictures, calendars and beautiful things for the covers. I discovered Gong, The Grateful Dead and Kate Bush, which was one of his particular favourites. He even made me an 'embryonic journey tape' of music which would have been around when I was conceived. He used to send me them in the post, my 'pixie post' is what I used to call it, and he would wait for my feedback on every one. People used to take the piss out of me for listening to tapes but I loved putting the

tape in and listening to it from the beginning right through to the end, just listening to the music in the order that it was supposed to be listened in. There is something very special about tapes. I can thank 'Mr Mushroom Man' for sharing his love of music with me.

<p style="text-align:center">★</p>

I went to university to study Knitwear Fashion Design. As a complementary study to my main course I chose Folk Studies – which I knew nothing about. After the first session, the tutor brought in a Martin Carthy LP record and she played a track that we had to discuss. It was 'John Barleycorn'. Something happened to me during that two to three minutes of playing. I was transfixed, moved. My life changed in those few minutes. After college I went down to Nottingham Library, joined, and took out a bundle of folk records which I can only say I consumed hungrily.

I had made a journey to folk music, then realised I'd been there all the time. Back home my dad had always played The Dubliners, Johnny Cash and Hank Williams. I just hadn't heard properly.

<p style="text-align:center">★</p>

I've always played guitar and just recently I've got into English folk music. I had an eye operation two or three years ago, I had a detached retina. I'd had the problem for nearly a week, I thought it was migraine, I'm a social worker, anyway, I just ignored it, my own problem.

It was when I was off work, for about four months actually, that I started to listen to more music. I began to listen to Led Zeppelin and as I explored its roots I found

folk. It's always very personal and significant. That experience with my eye, opened my eyes to a whole load of things – new music, my attitude to life, work. Now everything's much the same as it was before. I'm still stressed at work, but the music survived.

<center>★</center>

I can appreciate music and know what I like, I have it in my head but I just cannot seem to get it out. I have tried to play instruments, the piano and the bass violin, but as a friend of mine says, 'She makes a very good audience'. I'm with her on that. Being a good audience can be quite demanding, sometimes I feel like the odd one out. If I hear something that isn't up to scratch, I wonder if I should still applaud.

I think sometimes it can be a bit like the Emperor's New Clothes, no one wants to admit they don't understand or even like what they are hearing. I find World Music still full of surprises which is why I am drawn to it.

<center>★</center>

I like to feel connected to the music in the way I connect to people who I like, to memory that means something and just sometimes to the way I'm feeling on any particular day.

My list is very very uncool. In no particular order I'll go for 'Hold Your Hand Out You Naughty Boy' by the old music hall singer Florrie Forde, because it reminds me of my Auntie Alice, coming home from the sweet factory where she worked for hundreds of years with mint imperials in her apron pocket. Then I'll go for 'Ride a White Swan' by T. Rex because Tina McAllister once

kissed me in a youth club disco when it was on. Sutherland Brothers and Quiver's 'Arms of Mary' takes me to a council house on a rough estate which I shared with a some-time roadie who told me he worked with Pink Floyd; it was the first place I called home after leaving home. Next is Hurricane Smith singing 'Oh Babe, What Would You Say?' because I can hear my mother singing it while she did the ironing. And now I want Candi Staton to sing 'Young Hearts Run Free' because I'm on a wave of remembering and I want to wash up on the shores of a wild old party we had on the beach at Woolacombe in North Devon, when we all drank too much scrumpy and then stripped off our clothes to go skinny dipping at three in the morning. Now that's what I call a list. Just today's list of course.

Peace Boats

To see a world in a grain of sand
and heaven in a wild flower,
hold infinity in the palm of your hand
and eternity in an hour

Look closely and feel differently

Value your friendships

Keep happy, stay happy

Love is stronger than money

Take your chances and sail to your desires

Swim over, pushing right out to your fingertips
and free your mind to remember

The world is such a beautiful place.
Let's keep it so and love everyone everywhere

Music is the art that brings all people
together in harmony

Yesterday's history, tomorrow's a mystery
but today's a gift, that's why it's called the present

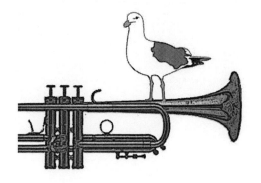

Sunday
Stories We'll Take Back Home

Shaking hands with everyone
Making It Happen

I have to say I absolutely love doing the catering for
Musicport. I couldn't do it without my merry band of
helpers of course. Every year we have a naming ceremony;
this year is Gary Guacamole, Charlie Carrot and Peter
Pumpernickel. We try to make sure that there is something
for everybody; vegan, vegetarian, as well as those who eat
all. The main aim is to make people feel happy about what
they have eaten. Last night I packed up some sandwiches
and fresh fruit for Mari Boine, because I know she likes
to eat on the way home.

When we first started they wouldn't let us do the
catering on site, so I just prepared baking and sandwiches
at home and left them in the dressing rooms. When they
said we could do our own catering I prepared the baking
and things that could be warmed weeks in advance, and
then I had a team of volunteers with ovens and I dashed
around collecting stuff from them to bring down to the
hall. This must be one of the few festivals where the
catering is done from home. It still thrills me to think that
Buena Vista Social Club have eaten food prepared in my
little kitchen.

The first year that we moved to the Spa we couldn't get
in the night before because *Antiques Road Show* was on and
we ended up washing up in a garden barrel in a caretaker's

cupboard. Now we do everything in the green room. I take a couple of kettles and a food blender and still bake at home before I go.

A few years ago I drove round the town at eight o'clock at night in a howling gale because Ali Slimani needed organic honey and we only had the ordinary. Little things like that make the difference. I have to smile when I see some of the riders, so many litres of sparkling water, so many still mineral water, lots of litres of beer and then when they come and I see how many are in the band I think, 'If you were to drink that litreage you would pop!'

This year we had a bit of fun on the first night. A lot of the singers ask for honey and lemon for their throats. I came without the honey and quite late on I had a request from one of the stage managers. I decided to make up a magic potion. I used white wine vinegar, sweet chilli paste, lemon and sugar and mixed it with hot water. Kate said to the singer, 'This is what my mother always made us for sore throats when we were children and it never fails to work.' The next night the singer was on again. Kate asked if she would like honey and lemon. The singer said she would much prefer the magic potion!

★

Musicport has been a yearly occurrence for nearly half my life. I arrived here on Thursday and felt at home with a group of people that has all the hallmarks of a family. Fortunately this family generally makes you laugh until you cry and isn't grumpy with you if you've been really crappy at staying in touch for a year.

I can't regale you with the stories of Musicport, there are too many. You really had to be there to watch a

procession that didn't process or hear a band explain that they are at the wrong venue, fifty miles away, only half an hour before their set was due to start. The truth is that most people wouldn't either, these are the woes that only cross the path of us squirrels that live behind the scenes.

I've just looked at my watch, then my programme, and the next band really should be showing their face soon. It's that time, midway through a set that stage managers begin to get curious as to the whereabouts of their next act.

<center>★</center>

I've been compering the North Sea Stage. We've had a great team in there this year, with Paul on sound and Rachel as stage manager. We've had a 'can do' attitude all weekend and things have run incredibly smooth. This is probably epitomised by the miracle of Jonny Kearney & Lucy Farrell. They were due on stage at 1:15pm on Sunday but their train didn't arrive at the station until 1pm. We still managed to get them in and on stage bang on time though.

<center>★</center>

I get some funny requests at the CD stall. A guy from one of the African bands came up and said, 'Have you got any English music?' And, of course you are working at a World Music festival and you've got your World Music head on. I said, 'Yes, yes, how about Waterson Carthy, the finest exponents of traditional English Music we have.' He said, 'Have you got any Robbie Williams?'

Most of the musicians have CDs to sell and will come to me on the stall and say, 'What's the deal Dave?' and we

sort out a deal and it's all pretty cool. Though there was a memorable incident with the manager of one of the Balkan bands. He was big, dressed head to toe in leather and looked for all the world like Russian mafia. He stood in front of me and said, 'You will sell CDs.' He got the inflection on every single syllable wrong, but I'm fairly sure that for fear of finding myself at the bottom of the harbour, I did him a deal.

Linton Kwesi Johnson came to sign books at the CD stall. He'd just done a poetry set and it had been lovely. Now on the stall, I had a wad of nine pound notes. They had been made up by the artist David Owen to send up the BNP. On the back of the notes it said 'Bent as a Nine Pound note'. I told Linton he could have some. He looked at me and his voice changed from that beautiful sonorous sound to cockney, he said, 'Nah, mate, I can't take that, you'll get me in trouble wiv the old bill!'.

<div align="center">★</div>

Concert photography is a very hard discipline, you've no control over lighting, crowd, performers. I only use natural light. Most concerts you've only got the first three songs to photograph. Here I can take my time, that's a rarity. Tinariwen from the South Sahara, they were the most artistically pleasing to photograph, all in full African costume, very visual. Happy Mondays, I liked them, full of energy and it comes across in the images. Shaun Ryder was a bit of a comedian, the energy in his music was superb. I photographed the late Gregory Isaacs on his last tour. He died not long after.

I've tried to play lots of musical instruments in my time. But eventually I got to the point that I had to admit to myself that I was shit. However, I have always been a good blagger, talking myself in and out of trouble. And it's this skill that ultimately led me to a life in the music scene. I was asked by someone if I fancied compering a few bands at gigs for a free ticket. Pretty soon I found myself booking the bands.

I ran the Trades Club in Hebden Bridge for a number of years. We could seat 140 people, or 180 standing/ dancing, though admittedly it was very cosy dancing. When I started there I could experiment with new acts because the club had a good reputation. People would come and see whatever we put on, there was an attitude of 'If the Trade Club have put it on, it must be good' and they'd turn up. This led to some great nights. It's not quite like that anymore, these days people want to know in advance if they are going to have a good time. It's been a growing trend over the last five years, in tandem with the credit crunch. This partly explains the massive rise in tribute acts.

It seems to me as more of the smaller music venues struggle, there are more festivals than ever. These are the places now where experimentation takes place. People turn up to see their favourite bands, but while they are here they will see a lot of musicians they have never heard of. And this is how new doors are opened and new music flourishes.

★

I live in a really rural area in north Wales and I got fed up with driving through to Manchester and Liverpool to hear

any interesting music, so I decided I would put on my favourite bands where I lived. I wanted a club environment so I settled on Hendre Hall outside of Bangor, which is a venue in the middle of nowhere with a courtyard, open fires and beautiful galleries. I have been promoting gigs there for the last six years and have been very fortunate in being able to have Justin Adams, Mighty Diamonds, Johnny Clarke and System 7 perform there.

One of the most talented World Music performers, Juldeh Camara who is from the Gambia and plays a Riti, played with Justin Adams at the Barbican in London. During the gig, Camara spoke to the audience stating, 'It's all well and good sitting down at these concerts but it would be great to have people dancing. Come and see us at Hendre Hall.' That comment was relayed back to me and made me feel so proud of what I had been trying to achieve.

★

Hearing Danny Thompson at Musicport 2003, tuning up his legendary double bass 'Victoria' that played on so many of my favourite albums, was the moment I felt we'd arrived as a festival. Then he kept saying, 'It's good here ain't it?' This festival has been my total obsession for the last twelve years. The greatest festival moment has to be in 2006 when the Buena Vista Social Club came off stage and were applauded to their coach. They walked through the crowd shaking hands with everyone as they went…

Born in a trumpet
A Story Of Note

I was born in a trumpet on a long hot tropical night on the island of Jamaica. The player of the trumpet had given birth to millions of notes just like me, but I'm not sure he realised just how important he and his trumpet were. He said he was 'just practicing' that night on the beach. But can you tell me please, when does practicing end and playing begin? As far as I'm concerned he played me into life that night on that far away beach, one hundred and twenty of your human years ago. I was born in a trumpet when a powerful blast of air bounced off a perfectly tuned piece of metal and shot out into the night over the warm, dark, Caribbean.

Let me introduce myself. I am a musical note. I am a Ceesharp. There are billions like me everywhere, most of the time you don't know we are there. But don't be fooled. In every breath you breathe there are musical notes like me hidden in the air and smuggled into your body with the atoms of oxygen and hydrogen and nitrogen.

In every mouthful of food and every sip of water, if you know how to look for us, you will find us. You see, a musical note like me is a vibration, a transfer of energy from one place to another. Once we are born and out there, we are eternal. At birth we are loud and strong and powerful and we leap into your ears and your hearts and

minds and you notice us. We help you remember places or friends, feelings you have had. We are so powerful we unlock your deepest memories and bring the far away to a place just between your ears.

Time passes. As the power of our birth dies away we become less and less audible. We never die, we just fade away until we are just the slightest tremor living in the tiniest gaps between atoms.

Enough about us, and more about me, Ceesharp. This is the true story of a long journey I made stretching over one hundred and twenty years from the night in a trumpet on a Caribbean beach. I was blown out over the waves and as I lost the power of my birth I slowly settled into the sea. I was lucky. Water, like musical notes, travels in waves. So when a note like me comes to rest on the sea, I don't bounce off like if I was a pebble hitting a rock, I blend in. It's more like how a ray of sunlight lands on sand: even when the sun has gone, the sand is changed by being brushed by the light and you notice the warmth that is left. So, I settled into the ocean and began my long journey. Did I mention that musical notes don't die, they just fade? Well I should also tell you that we can be reborn. With over one hundred and twenty years of travel through the ocean, I have been reborn many times. You have all heard how whales can sing to each other over vast distances. They do this because as they breathe water in, looking for food, they also breathe in musical notes hidden in the particles of water. Once inside, we are irresistible! The whale has no choice but to sing us out again; powerful, resonant and full of meaning.

What you might not also realise is that just as whales sing, so do other water creatures. You ever seen a goldfish?

Look at its mouth and notice it's always open. Do you know why? The fish is singing and giving rebirth to one of us notes that it has swallowed in the water. Think about it. You know it's true! Even the ocean itself uses musical notes. Remember the last time you stood on a beach? Now remember the song the sea sang to you as it moved towards and away from you. You might have been hearing me as the sea used what was in it to pass on cultures and serenity to warn you of a storm.

So it was that I passed many long and happy years, a musical note, Ceesharp, born in a trumpet and travelling through the sea. Warm, friendly currents drew me south for a while. Storms took me to the far north, froze me into an ice-flow for twenty years, and then blown in spray in front of a mighty hurricane. Eventually, I found myself in a narrow stretch of northern sea. Borne on a strong tide and a sharp wind, I found myself irresistibly drawn back to the land. There is a crash and a jolt as the sea is smashing against unyielding stone and I am released once again in the air and carried on the wind to a building that reminds me of the colour of a Caribbean beach. Once inside I find myself in room full of notes like me and for a few days I live a life of rebirth. Captured and released from an African kora, the strings of a hurdy-gurdy, squeezed out from between the cymbals of a Buddhist monk, plucked from a bass guitar and blown from a clarinet, each rebirth giving me new strength and purpose.

And where do I land next? And where will I spend the next part of my existence? Who knows. But if you shared these few days with me, think back and notice what you notice. Remember if you can the best moment of your weekend. Chances are that it involved some music. That

music was made of notes like me. Maybe it was me, and if so, thanks for letting me travel with you for the next bit. Know that I won't die and if you keep remembering me, I won't ever fade away.

May this one last forever
Magic Moments

I'm sixteen, live here in Bridlington with my mum and sister. I go to Headlands School where I'm doing A level music and a BTec in music from different cultures. I started doing gymnastics when I was only two years old. I used to see the older girls dancing and thought that's what I wanted to do, so then I went to Collette Tyler's Dance School in Bridlington.

I've never sung on the Spa stage before but I really enjoyed doing this. We met the band Asere for the first time at school on Tuesday. Only one of the band speaks English and when they were talking and laughing together we all wanted to know what they were saying. I learned a few Spanish words like 'hola' which is hello.

The best thing so far about Musicport is that we got to meet Goldie's Band. Everyone was really hyped up to meet Theone because we are all music students so everyone really wanted to impress him because he is a producer as well. All the girls were swooning over him and he gave his necklace and hat away. We all improvised together, he's really kind and he wants to help everyone.

★

I was playing in a pub in Leeds with a man off a trailer site, I played flute at that time. It was a crowded Irish pub

with a lot of musicians on the stage. Some of them tapped their feet. He leaned over and said, 'That foot tapping's not right, all the rhythm should be in your playing.' Ever since, I stopped tapping my feet when I play.

Back in Brid, I was playing my fiddle doing that Dire Straits song 'Walk of Life' and I was being filmed by Yorkshire TV. The camera man was right on me and panning down. I knew he was looking to go from me bowing the fiddle to my tapping foot. When he got there, I wasn't tapping. He gave me a look that I shan't bother to describe.

<center>★</center>

In a Drumming Circle we all sit round with giant African drums called congas or bongos, and use hands or drumsticks with a round end like a small ball. There's a leader and we try to follow him. Sometimes we have to tap out a chant like 'Chitty chitty bang bang', learning phrases like that makes it easier to learn the beats. The magic thing is that at some stage when you're playing, you become the groove, sinking into the wider group. You feel the vibrations in your body. Drums communicate without verbal or visual signs, and is part of a shared experience. It's also something primal, like the heartbeat.

<center>★</center>

Joy Division's song 'Love Will Tear Us Apart' is one of those, what they call these days, iconic songs. You might think that nobody can do anything else at all to it that can either add to our understanding of, or show us that there can be another way of singing it. On the Saturday night here Mary Coughlan shined a light on it that made me see and hear things that I had never even thought of before. She

found a way of telling the story of that song, so that it opened up whole new meanings. And in a voice that so hushed everybody you could have heard a pin drop or even the waves lapping up the sea wall. It was one of the real highlights for me this year.

<div align="center">★</div>

My favourite singer here at the festival is Chris Wood, he's written an incredible song about the Brazilian man who was shot by police in the London tube. I also love the Galician pipes, played through the mouth; my wife wonders if the fact that the musician is a young sexy lady has anything to do with it.

<div align="center">★</div>

I cried when Chris Wood played 'One in a Million'. It's about two people who work in a chip shop and there is tragedy in the middle but then it improves. It still made me cry though.

<div align="center">★</div>

Geoff Berner comes from Vancouver and sings Jewish drinking songs. He opened the North Sea Stage at 6pm on Friday night. By 6:40pm he had everyone in the room singing 'Fuck the police'. He's my kind of man.

<div align="center">★</div>

Trumpets of Death made me feel like I was seventeen again and listening to Frank Zappa stoned out of my mind. 'Experimental' would be a very kind way of describing them. A few of the older crowd popped their head round the door, had a quick look and popped back out again. I

really admired the older ones who sat there through it all though. They are the kind of people who have that attitude: that they really like what young people are trying, even though they don't understand a bit of it. I really like that attitude. If you can't experiment and take risks with music at that age, when you're taking risks and experimenting with life itself, then you'll never be able to.

★

It was in the late eighties when Andy Kershaw presented his late night Radio 1 show that the Lancashire presenter introduced me to African dance music. Little did I know that many years later as a musician I would be performing the kind of music that Andy had previously brought to my attention. To hear Andy talking at Musicport was a special moment for me personally.

★

I am a reluctant Musicportist, I'm only here for a bit of a shagfest weekend away with my partner who really likes World Music – likes it a lot. So that's a bit weird, it is entertaining though. The girl from the Ethiopian band is fantastic – she really knows how to shake her booty – it's her culture, she was born to shake her booty and she knows it. I would really like to ask that Ethiopian girl what she thinks about all the old hippies. Actually she is doing a great job working her crowd – and who am I to talk because, what is this? I am quite enjoying it too! What I really like is later when I see her again in the crowd, she has obviously been to Top Shop and is dressed exactly like my 18-year-old daughter in the latest western fashion.

The Cajun dance workshop is good – I like it – but sad

to say though mainly because I am quite enjoying traumatising my boyfriend who clearly can't stand it – but feels that he has to do his best to help me to enjoy myself – bless. Ah but when we found the acoustic stage and, relax, everyone was seated, it is dark and cosy, and what's this? Am I tapping my toes? What is this band called I hear myself say – I like this band – they are playing something familiar from a film I have seen – this is really great. As I come out I hear some words coming out of my mouth – I think I might get a ticket for tomorrow afternoon after all – I quite fancy Faerd, Dorge, Becker & Hjetland.

<div align="center">★</div>

I'd been listening to jazz, rock, pop, classical – all the things we know in Western music. Then I attend a World Music festival and hear the sound of instruments I didn't even know existed. How beautiful the sound is in every way: emotionally, spiritually, and intellectually.

Quite often western music doesn't relate to life like that of folk singers singing about their horses, or the tribesmen in Africa singing about their camels and about women working. Music is part of life.

<div align="center">★</div>

They say don't they that you should never try to meet your heroes but having met Robert Plant on a few occasions I have to say I don't believe that, he's a smashing bloke. I first met him in 1990 backstage at a concert, he turned up late in a minibus.

Not long after that I started a fanzine dedicated to his work. It's called *The Lemon Tree*. I edited and put that together for seven years. It's now a page on Facebook.

I'm here at Musicport through Robert Plant's influence. Through his love of Bulgarian, African and desert music, I have now become entranced by those forms. Through Robert I came to know the work of Justin Adams and then to Juldeh Camara. What a journey. Led Zep to Bridlington with enthusiasm. Thank you Robert Plant.

★

I've done music, compering and touring on and off for twenty-five years. I've met lots of famous people, Tom Paxton, my favourite folk singer, Dick Gaughan, Rolf Harris, most of them lovely people and I've never tried to be star struck. I always tell myself that they're just ordinary people like us. Last night I met Hugh Masekela, he doesn't do hand shaking, he just hugs. Suddenly it struck me mid-hug, 'I'm being embraced by Hugh Masekela' and it got to me. After all these years I'm hugging Hugh Masekela and I'm absolutely star struck. I'll be ninety and telling my great grandchildren that one.

★

I'd like to say I grew up with The Beatles, anybody coming up in the 60s will say that. And in a way I did, I liked their music. The truth though is that I grew up with The Watersons. I was underage drinking while at school in the Blue Bell upstairs room. The Watersons had their folk club there and when they sang, particularly Norma, nobody moved, you hardly dare to breathe. I've come out of that place into the cold night with my hair standing on end.

I knew that I was connected to the Watersons music because of where I was from. I grew up on the Hessle Road and my parents worked in the fish factories. In my

later teens I got seduced away from that by rock and pop, because it speaks of love and sex and stuff and that's what I wanted, but I didn't stray far.

When I saw Hugh Masekela here at Musicport this weekend he spoke to an audience that rippled with a wave of recognition about what he was saying. Someone asked him, 'When did you first become aware of politics?' He said, 'From the first time I could think.' So, for me, it all comes to The Watersons in the end. Folk music became unfashionable, almost laughable, because it speaks about politics of events, about strikes, evictions, injustice. Then you realise that there is a connectedness and that the core of life and music cannot be separated.

<center>★</center>

I met Hugh Masekela at Ronnie Scott's Jazz Club in 2000. I treasure my copy of the programme and the review I snipped from the *Guardian* the following day.

At the time I was teaching in Whitby and every year I took a group of A level history students to visit London; The Tower, Houses of Parliament, and so on. It became our tradition on one of the evenings to go to Ronnie Scott's Club. In the audience with us were the cast of *The Lion King* on a night off. They all joined in when Hugh Masekela sang a particular song.

Hugh was in the bar at the interval between sets. I got talking to him and told him about the students. He said, 'Please bring them in to say hello.' All ten of them trooped in. He greeted them all so warmly. He was thrilled to talk to them about education. He wrote on my programme, 'Live, Love, Teach and Learn' and he signed it in red pen. The writing is almost faded now because I've been

displaying it on a wall. I brought it with me this weekend in the hope that I get the chance to ask him to go over it.

When I saw him come into the green room at this year's festival, I took out my programme and went over to him. I told him about the night at Ronnie Scotts. I'm sure he didn't remember, but he was charm itself, he even gave me a hug. He wrote on my programme again. 'May this one last forever.'

<div align="center">★</div>

After the Hugh Masekela performance my sister-in-law went backstage to say hello and to tell him that she had worked with Bishop Trevor Huddleston. They got talking and Masekela asked her if she'd ever been to South Africa. She said that she had and that her husband was South African. When she mentioned his name Masekela said, 'That name's familiar.' It turned out he went to school with her husband's sister. Just goes to show that this small world is full of connections.

<div align="center">★</div>

Late on Saturday night I was driving past an hotel and noticed the black hats of the guys in Hugh Masekela's band, I could see them above the window sills. I stopped the car, took a deep breath and went in. It was just the band and a woman minder. Hugh wore a black felt hat and woolly scarf. Later they were catching a plane to Latvia. I asked if he minded my coming in and interviewing him – he replied yes he did mind, but nevertheless was warm and laughed and gave me a hug. 'I don't do personals,' he said, and told me I had to ask the lady over there. She said 'Absolutely not.'

I went to say goodbye, God bless and safe journey and said I was amazed by his energy. He said, 'I do Tai Chi.' I told him my friend said she wasn't afraid of growing old after seeing him; he laughed – 'The teenagers are jealous of me.' I asked if it was hard to come down after a gig, he replied 'You must never come down. That's suicide. You only come down when you die.' He referred to the afternoon talk he'd done – where he'd not let the interviewer speak – and said I should get a tape of it. 'It has the meat in, and the sausage.'

There was a view of cliffs outside the window and I told Hugh I lived on the edge of cliffs at Flamborough. He said he envied me, which left me stunned. He said, 'They've taken the white cliffs of Dover and put them in Bridlington.' Wearing his hat and knotted scarf, he looked younger than the man on stage. He'd been warm and gracious and reached out to hug me before I left. I thought he was a bigger person than the big person I'd thought he was previously.

<p style="text-align:center">★</p>

I've just watched Mari Boine and been outside the front door for a smoke. As I stood for a moment in the still of the night I reflected on what I'd seen over the last three days. It's sometimes easy to be nonchalant about the experience here, moving from stage to stage, and at each stop-off point being confronted with something unexpected. After a while the exotic becomes normal, the exposure to live music becomes the routine. As I watched Mari Boine sing her final song I'm sure I'd managed to forget the person who arrived here on Friday night, all harried and hassled after a hard week's work and drudge.

But then as I dragged on the last of my cigarette I listened to the sounds of the Bridlington night. Two young men were yelling at each other some way off to my left and in front of me I heard the strangled sounds of a karaoke rendition of Queen's 'I Want To Break Free' drifting out of the Southcliffe pub opposite. I looked through the pub window at a middle-aged man swaggering about with a microphone in his hand, slurring at a handful of punters. And then I thought about tomorrow.

★

We came out of this year's festival before the end. We wanted to be home and get a good night's sleep because our Eddie had a piano exam in Leeds early on the Monday morning. I heard the ethereal sounds of Mari Boine as we went through the door, then the sounds of a very bad karaoke singer doing 'Chanson d'Amour' in the hotel bar across the road. We listened to the sea and the wind and some fish and chip papers blowing down the street. I looked up to say thank you to the moon for bringing us in and out again on the tide. A mate was picking us up and was waiting in the car. We strapped our seat belts on, our mate said, 'I don't know why you picked this weekend to come here. You've missed a right bonfire display.' I started to tell about the monks and the mandala, it washed over him. He didn't even hear me I don't think, he just said, 'If we get a clear run we should be home for just after eleven.' We powered down the road on the edge of the Wolds that links Bridlington to the M62. I watched the car headlights catching rabbits scurrying about on the grass verge like a scene out of *Watership Down*. My mate said something about myxomatosis, but I was drifting off thinking about

Mary Coughlan and love tearing us apart, about Hugh Masekela's trumpet and about our Eddie's lovely smile when he played Fats Domino's 'Blueberry Hill' on the baby grand piano on the Saturday afternoon and loads of people gathered round the Joanna to sing like we did in the olden days.

*

Over this weekend I've watched a group of Tibetan monks carefully paint an intricate pattern with sand, only to mix it together and then throw it into the sea. I've never come across this practice before but they explained to me that it symbolises the temporary nature of life. It seems fitting to learn that here in Bridlington; a place where a group of people with a thousand different lives come together to make something that has a very special place in my heart. For only five days later there is little or no physical trace that it has been here.

Contributors

Giving thanks for sharing their stories

Jude Abbott
John Allsopp
Fiona Barnard
Steve Barnard
Sue Bateman
Irene Becker
Drew Black
David Boardman
Quentin Budworth
Steve Burns
Sheila Carmicheal
Rob Carmicheal
Penny Chaloner
Sean Chandler
Edward Clayton
Ian Clayton
Christine Cleaves
Glenn Coggin
John Colledge
Nick Cooper
Fiona Cooper
Mary Coughlan
Lenore Craggs
Ian Daley
Egbert Derix
Ryan Dockray

Phil Dodd
Sarah E A Drummond
Jim Eldon
Dewi Llwyd Evans
David Fearnley
Carol Ferguson
Ian Ferguson
Neil Ferguson
Terry Flynn
Sue Green
Liz Hames
Gary Hammond
Jon Harrison
Keith Hawley
Nicky Hollins
David Holman
Kev Howard
Ann Howdon
Dave Howdon
Byron Johnston
Cath Johnstone
Charlotte Jones
Ron Jones
Emma Jones
Christine Kell
Andy Kershaw

Jacab King
Gillian Leach
Richard Lee
Rob Lloyd
Sammie Lloyd
Thogmet Lobsang
Dave Longmate
Amanda Lowe
Paul Lozynsky
Mark Lozynsky
Denise Magson
Ian Mason
Iain Matthews
M McBreen
Corinne McDonald
Deirdre McGarry
Karen McCarthy
Jim McLaughlin
Keith Mollison
Colin Mulligan
Jacqui Mulligan
Derek Nicholas
Chandran Owen
Rob Pagett
Rosemary Palmeira
Heather Parkinson
Claire Parks
Ian Parmley
Wayne Pearson
R Pearson
June Pearson
Richard Peters
Ian Pigg
Fabricio Porongaba
Neil Record
Sally Richards

Bea Roberts
Terry Scott
Ayo Scott
John Sewell
Sally Shaw
A Sheldon
Eileen Smith
Geoffrey Smith
Peter Smith
Neil Stead
Ann Stead
Sinja Streuper
Mim Suleiman
Charlotte Swain
Brian Swinton
Mark Thompson
Roz Thompson
Joy Wales
Janet Watson
James Weyman
Peter Wilkes
Christine Withers
Wendy Woodfords
Saeeda Zaman

To The Writers

Ian Clayton
Lenore Craggs
Ian Daley
Emma Jones
Jacky Lawlor
Deirdre McGarry
Rosemary Palmeira
Wayne Pearson
Heather Parkinson

Further stories from a world of music
www.route-online.com

Bringing It All Back Home − *Ian Clayton*
When you hear a certain song, where does it take you?
What is the secret that connects music to our lives? Heart
warming, moving and laugh out loud funny, *Bringing It All
Back Home* is the truest book you will ever read about
music and the things that really matter. 'The literary
equivalent of a great evening in the pub.' − *Songlines*

The Train of Ice and Fire − *Ramón Chao*
Colombia, November 1993: a reconstructed old passenger
train, bespangled with yellow butterflies, is carrying one
hundred musicians, acrobats and artists on a daring
adventure through the heart of a country soaked in
violence. 'Maybe it was the best adventure I ever had.' −
Manu Chao

Away From the Light of Day − *Amadou and Mariam*
This inspiring autobiography reveals the source of Amadou
and Mariam's contagious music, threading its way between
tradition, religion, hope and superstition. 'The picture
Amadou paints of West African life in the 60s and 70s is
vivid, and it is impossible not to be impressed by his refusal
to ever feel sorry for himself.' − *Mojo*

Lightning Source UK Ltd.
Milton Keynes UK
UKOW04f0731300815

257758UK00002BA/20/P